HOW TO MAKE MONEY WITH
DIGITAL PHOTOGRAPHY

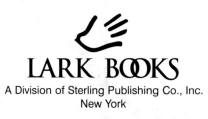

LARK BOOKS

A Division of Sterling Publishing Co., Inc.
New York

HOW TO MAKE MONEY WITH
DIGITAL PHOTOGRAPHY

Dan Heller

Book Design: Tom Metcalf
Edited by Haley Pritchard
Editorial Assistance: Delores Gosnell

Library of Congress Cataloging-in-Publication Data

Heller, Dan.
 How to make money with digital photography / Dan Heller.
 p. cm.
 Includes bibliographical references and index.
 ISBN 1-57990-678-8 (pbk. : alk. paper)
 1. Photography--Digital techniques. 2. Photography--Business methods.
 I. Title.
TR267.H45 2005
775'.068--dc22

 2005006954

10 9 8 7 6 5 4 3 2

Published by Lark Books, A Division of
Sterling Publishing Co., Inc.
387 Park Avenue South, New York, N.Y. 10016

Product names are trademarks of their respective manufacturers.

Distributed in Canada by Sterling Publishing,
c/o Canadian Manda Group, 165 Dufferin Street
Toronto, Ontario, Canada M6K 3H6

Distributed in the United Kingdom by GMC Distribution Services,
Castle Place, 166 High Street, Lewes, East Sussex, England BN7 1XU

Distributed in Australia by Capricorn Link (Australia) Pty Ltd.,
P.O. Box 704, Windsor, NSW 2756 Australia

If you have questions or comments about this book, please contact:
Lark Books, 67 Broadway, Asheville, NC 28801 (828) 253-0467

Manufactured in China

ISBN 13: 978-1-57990-678-8
ISBN 10: 1-57990-678-8

For information about custom editions, special sales, premium and corporate purchases, please contact Sterling Special Sales Department at (800) 805-5489 or specialsales@sterlingpub.com.

contents

foreword

Until recently, for most people the business of photography was a sole career. In the past, images had to be printed in order to be marketed, and portfolios, mailers, and other marketing pieces had to be made and sent out. By far, the biggest "cost" was not so much money as the time required to do all these things (though money was still an important factor). In those days, even an established professional required a major infrastructure to manage the kind of volume necessary to generate enough business to live on.

The only feasible way to make money was to have an employer or an agency to handle marketing and sales to thousands of customers. To acquire this representation, photographers needed to have invested significant time in their craft to achieve the experience and credibility necessary to be chosen by an agency or employer. In the end, it was rare for everyday people to make any money at photography, regardless of how talented they were.

Two things evolved over the course of the 1990s that changed the entire landscape of the photography industry. First, the price of quality digital equipment and output became accessible to the consumer public, bringing down the time and costs of producing professional-quality images. Second, the Internet created a venue that allowed people to overcome the distribution barriers of the past. Today, anyone with quality consumer-level equipment and an Internet connection can make their images instantly available to billions of people around the world. Time and financial investments are low enough that anyone can make some degree of money with their photography. However, because of its accessibility, the Internet photography market has been flooded with millions of eager snap-shooters. The good news is that the market has also exploded to include millions of eager buyers, many of whom might never have bought images if not for the Internet.

While there still are segments of the photo industry that require considerable time, effort, and other resources, the nature of today's industry and the marketplace allows everyday people to achieve a modest income without having to make photography a full-time career. Even so, making money at photography takes effort, no matter what level of income you're aiming for. If it were easy, everyone would succeed, which certainly isn't the case. The important thing to remember is that making money with photography is more about good business sense than anything else.

In starting a photography business, the question is not so much what to do, but rather how you should do it. There are no secret formulas or checklists that assure success. Achieving your business goals will only come as the result of a careful analysis of what works and what doesn't for your particular lifestyle and long-term artistic and financial objectives.

The information provided here will help you to determine which steps are most appropriate for your business model, and how you can best implement them. This book will become a tool that you can use to make more informed decisions about issues that arise as you go through the process of, well, making money with your photography!

PATHS TO
THE PHOTO BUSINESS

read this first

Don't tell me, I know. You like taking pictures. A lot. Admit it. Oh, it starts innocently enough. A few snapshots here and there—parties, social occasions, and the like. A social photographer, you claim. But it's not enough. You start taking pictures first thing in the morning, late into the night, and sometimes even at work! The habit just has to be fed, so much that you foolishly want to quit your job and do it all the time. Perhaps you rationalize, "Maybe I can just get a little income from it. That won't hurt, will it?" Before you know it, you're going to photography meetings, confessing your weakness for that great new digital camera. There you are, in the dark, with all the others just like you, showing slides, listening to stories about how someone took pictures on a safari or in Hawaii. And then, (gasp!) someone announces they just sold a picture to a magazine. A hush befalls the audience.

Well, you can come out of the shadows now and hold your head high. Your passion is nothing to be ashamed of. Unlike everyone else, I'm not going to talk you out of it. In fact, I'm going to spur you on. But, before flopping open your wallet at the camera store, sit down. We have to talk.

paths to the photo business

There are many paths people can follow that lead into the photography business, but they will fall under one of these three basic categories:

Hobby/Enthusiast

Student/Traditional Path

Migration from Another Career

Because people's objectives in life vary, there is no "correct" path into the photo business as the end goal may not always be the same. One person may want to just have fun and pull in a few dollars to pay for the hobby, and someone else might want to put his kids through college. Many drift from one goal to another, as conditions in their lives change. (For example, I started out as a hobbyist and ended up making a pretty substantial career out of it.) Your objectives may vary, from the strength of your pho-

to mere "painting by the numbers," especially in the world of photography. There are no secrets, whether it's becoming the celebrity star photographer for the cover of Vanity Fair magazine, or entering the less-glamourous greeting card market. Any task can be fraught with little "gotchas" that no book can prepare you for in simple terms. At the end of the day, if it were that easy, everyone would do it.

It's natural to think that if someone else can do it, so can you, especially when you see the kinds of pictures that are used in magazines, postcards, and art galleries. It reminds me of the joke:

Q: How many photographers does it take to screw in a light bulb?

A: Fifty. One to screw it in, and 49 to say, "I could have done that!"

Photography as a skill isn't technically hard, though creativity takes time to develop. While truly unique artists are less common, to make images good enough to sell is relatively easy. That's why the joke above applies; most photographers with reasonable competency can look at "commercially successful" pictures and say, "I could have done that." But this isn't what makes a success out of photography. It's having business sense. It's knowing what to shoot, and how to sell it. You can probably make a good living shooting shoes for catalog companies, but is that what you really want to do? Because of the nature of the business, and of your lifestyle goals, the first thing you need to do is envision what you want out of photography, then what you would want out of a photography business.

This is my last quote on the subject: "Trying to make a career out of photography is a sure way to ruin a perfectly lovely hobby." Photography is more of a lifestyle than it is a labor that one does to earn an income. (It is very rare that people go into photography because they can't find another way to make money.)

tography ambitions down to the lifestyle you are (or aren't) willing to endure. Also, your own past experiences in life and career greatly affect your potential outcome and financial needs. But, take note: While there are often tradeoffs between your many goals, don't fall into the trap of believing there is one path to success, or that there are strict rules for succession.

No matter who you are, you will eventually learn the first rule of making money that applies to any and all business models: "If it were easy, everyone would do it." This is my main mantra. You can make money, but it's simplistic to think that it's just a matter of doing tasks that someone tells you to do, having the right forms, looking at a pricing chart to price pictures, or getting the right portfolio to art directors. No business can be dissected down

money and photography A costly mistake people make about the photography business is believing that they can buy their way to success (as with other capital-intensive businesses that require cash to start). This is not the case; you can't buy opportunity.

Q: How many photographers does it take to screw in a light bulb?

A: Fifty. One to screw it in and 49 to say, "I could have done that!"

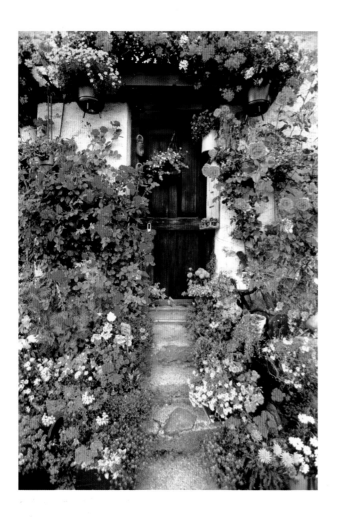

No one cares that you bought your own ticket to that African Safari and got pictures of cute little leopard cubs. Nor does it matter that you are willing to shoot an assignment "for free" if you don't have the credentials to show your knowledge about the subject or to demonstrate your skills. And it wouldn't even cross someone's mind to consider you over someone else because you had more expensive equipment.

The perception that money buys access or success is one of the more "senseless" ideas that permeates the photo industry from pros to amateurs. Often, people who retire with extra money go into photography believing that, because money isn't a barrier for them, they'll rise above others without much effort. Equally as erroneous is the belief by some professionals that wealthy amateurs who only want to get published are hurting the photo industry because they don't charge much (if anything) for their images.

Both the amateurs who think money will help them get ahead and the pros who believe that wealthy amateurs hurt their business are wrong about their perception of money's role in photography. The amateurs will find that they've spent a lot of money on an elaborate hobby and that, while having a hobby they enjoy is great, the scant opportunities to have their images published don't really amount to a career. As for pros whose careers are stagnating, it's just not as simple as pointing the finger at amateurs. These pros clearly have other business problems that go way beyond the efforts of a few wealthy amateurs.

There are a few photo business models that do require more significant capital, such as a studio photographer doing high-end product shots that involve substantial lighting equipment and big, roomy space. These requirements can be quite prohibitive, especially if you live in an expensive city like San Francisco or New York. But, just because one can afford it doesn't mean that he or she is ahead of the competition. One still needs to compete on experience, portfolio, and credibility within the advertising community. Resourceful amateurs who have very little money to work with are forced out of necessity to network within the community and establish relationships with existing studios. By consequence, they often learn more and gain more credible experience than their wealthier counterparts who try to go it alone.

Q: What's the difference between a photographer and a large pizza?

A: A large pizza can feed a family of four.

the serious
photographer

Okay, let's put this into context. Regardless of what path you choose to enter this business, when it comes to making money with photography, there are two kinds of people: the serious photographer, and the insanely serious photographer. The primary difference is one of lifestyle. You may think that you're just a casual hobbyis who simply wants to pick up a few dollars for your pictures, but by the time you actually get those dollars, you'll have invested considerable time and effort. That's the serious photographer.

By the time you've really achieved that "few dollars" level, maybe you start thinking that "just a little more effort" can yield considerably better returns. It's sort of like buying a soft drink in a movie theater; the smallest cup you can buy is ridiculously expensive, but for just a couple of quarters more, you can get twice as much. That's what the photography business feels like. And by the time you learn that "just a little more work" is not nearly enough, you've done it anyway. Now you're the insanely serious photographer.

How you see yourself is really what will determine where you end up. Are you "the hobbyist that wants to make money," or do you want to build a real, bona fide career? The two tracks are so completely opposite of one another that you could actually do yourself more harm

than good trying to make a career using the strategies of a hobbyist. Similarly, the hobbyist would quickly lose interest by trying tactics that only the professional photographer should use. Put another way, making short-term income often involves tasks that have no long-term benefit. There is a limit to how much you can make as a hobbyist simply because the tasks and methodologies are so brute-force and simplistic that they can't be automated cost-effectively to yield any appreciable income.

An example of this is the postcard business: You can make some money, but just getting to a point of generating revenue requires work and time that, if invested in other areas, yield more profit. Is the payoff worthwhile? For the amateur looking to tool around in a car visiting gift shops around town or in a vacation spot, the experience alone is often joyful enough. But, don't expect to raise a family on this strategy without having expanded into something that's no longer considered a "photography business." That is, people who make a living in postcards alone are usually in the distribution business with only a little time spent doing photography.

Given choices of how to invest time and resources, pro photographers differ from hobbyists in this way: Hobbyists put lifestyle ahead of business; they photograph for fun, and then figure out how to make some money from it. Professionals also love photography, but they focus on choosing options where there is opportunity for long-term growth and name recognition, which contribute to higher pay and recurring business over the long haul. Note that these two types of photographers are two ends of a very wide spectrum, and not everyone is at one end or the other. People often find themselves somewhere in the middle, and finding your place is your first objective. As you do your soul-searching, remember this quip: "What you do to make money as a hobbyist is not what you do to develop a career."

One of the middle areas that hobbyists and professionals share (where it's often hard to differentiate between the two) is the "vanity" business. This is where your main goal is to express yourself and your ideas. In this business model, earning income is secondary. An example is a "vanity gallery," where artists own the retail space in order to exhibit and sell only their own work. Other examples include selling prints at art festivals, cafés, or county fairs. Any of these are fun, rewarding, and even profitable. I've known many people (including myself) who have made some money at these venues, but the path to financial success here is more ambiguous.

Among certain demographics, and in some geographical regions, the vanity business can be profitable to the point of supporting a family, but these are exceptions. Usually, the photographer is extremely well-known, or the artist has a large, rotating clientele in tourist-laden cities like San Francisco, New York, and Los Angeles, or "art Meccas" like Santa Fe, New Mexico. It could also be that the vanity gallery is an adjunct to a much more active photo business, simply selling business by-products.

Not all vanity businesses are elaborate or involved. In fact, many aren't even necessarily profitable. Examples include photo books or postcards, where the primary focus is to bring attention to the artist (i.e., these are regarded more as marketing tools than as income generators). Pros who've migrated away from their more established photography careers into vanity businesses often do so as a form of pseudo-retirement—they can leverage their existing stock of successful images as annuities that bring in residual income without having to remain as active as they used to be. In summary, the vanity business is best accomplished when you're either laid back about your longer-term ambitions, or when you use it as an avenue to pick up additional revenue from images already created through other business means. Either way, this is rarely the end-objective for the career-minded photographer (although it may certainly be an exit strategy after loftier goals have already been accomplished).

the insanely serious photographer

There are those who are so intent on becoming a photographer that they have considered animal sacrifice. At a very early age, they have visions of photographing supermodels in bathing suits, car ads for magazines, or war zones and other breaking news events for newspapers. (The family cat looks upon these young people with caution.) There are others who get the itch at an older age, deciding that they've had it with their current careers and need to change to something entirely within their control so they can attack it with all their remaining vigor. For the younger members of this group, there is the option of going to photography school. Older adults usually consider a direct migration path.

photography school
I have two extremely strong points of view on photography school—okay, three:

1 It's the perfect (if not the only) option.

2 It might be a good choice, but there's a lot about the industry that you can't learn in school.

3 It's an incredibly bad personal decision. You might as well spend your money on a good therapist, because that's where you're going to send your parents when they see what's become of you. (Picture yourself in a coffee shop reading the "want ads" and griping to friends about how unfair the world is for an artist.)

Strong Advocate of School: For the emerging art photographer or photojournalist who wishes to follow a more serious path—to "make a statement," or to have influence (or at least an effect) on the art community or world events—I am a strong advocate of going to art school. In fact, you should get a Master's degree from a reputable university, or failing acceptance there, a specialized photography school. If that doesn't work out, get a regular degree at a normal college and take a lot of art classes. (If none of these options is desirable, you could always get one of those fake diplomas online.)

Most successful artists and photojournalists emerge from academic circles. Of course, there are myriads of exceptions, but statistically, they come from fine art schools. Educational programs provide avenues to resources and networks of people who can lead students through the labyrinth of this quirky and often unforgiving realm. You come out with credibility that is respected by people and venues where you'll establish your career. It's such a tight-knit world that, if you're not in school, you may find it hard to compete against those who have access to the movers and shakers in the industry. While I do believe that photography school is imperative for certain people, I also have some reservations about this avenue. Hence, my second view of art school:

Moderate Support of School: When it comes to younger people considering college for a commercial photography track, I'm sort of "in the middle." You definitely get a good education and hands-on knowledge on how to do things like configure studio lighting, put together a portfolio, send out marketing postcards, and various sundry tasks associated with running a business, but these are things you can learn on your own.

Photography is a formidable and honorable career, and networking on the inside can be useful for the top students in the class. (Thus, the benefit of school.) Competing in the outside world, however, where you have to go up against non-academic types who compete tooth-and-nail in ways that school didn't teach you, well, that's another thing.

The photo world is very competitive, and doesn't pay well. And that's the good news. The bad news is that it's also terribly unfair and unforgiving. To succeed, you need to learn business skills and ideas that will be more responsible for your success than whether you know how to configure studio lights to yield a 2:1 lighting ratio. Most photo schools teach nothing about the real world of the business, and what they do teach has been made mostly obsolete by how business (not just technology) has changed since the turn of the millennium. I'm not talking about digital photography, using Photoshop, or anything like that. I'm talking about how photographers can no longer build businesses on the same foundations that they used to.

If it sounds like I'm trying to talk you out of photo school here, I'm not. I'm just concerned about putting all your eggs in one basket with your education unless you're really, really sure—you know, "insane." (I realize you've probably already heard all this from your parents. But remember, I'm not your parent.) And I'm no longer inside parentheses, so you can't pretend you don't hear me. Which leads me to my third perspective:

What-EVER!: As long as you're going to college, I'm happy. A well-rounded education and a rich set of life experiences will make you a better artist overall because you'll learn to see multiple perspectives on broader world issues. And besides, you can always do photography alongside anything else. Just about any other career can also involve photography in your "spare time." (And if you're that wild about photography, I guarantee you'll find that time is copious.) You're also fortunate; photography isn't expensive, and it doesn't require anyone else to participate (unlike that rock band you had back in high school). If you evolve and grow your photography to where you're making money, great! You can always quit your other job then.

migrating
to photography

If you're past college age, chances are that a career in photography is a migration from another job. The majority of the population has been taking pictures for years despite having had no formal training in photography—and a huge percentage of these people are very good at it. This is partially why many people feel like a migration to the photo business is an arm's length away. So, for these people, it's an alluring prospect to give up their day jobs, or enter into retirement and pick up photography fulltime. What isn't expected, however, is that 90% of the photography business isn't taking pictures and living the romantic life; it's managing your business. For this reason, most people who migrate into photography drop out.

Remember, what we're talking about here only applies if you're looking for photography to be your career. If it's just a small, money-generating hobby, the business management aspect needn't be so time-consuming or troublesome. In this case, the migration path can be more attainable and fun. If you have a realistic idea about what an "arm's length" is, and reasonable financial expectations, you're set.

the scope
of this book

Essentially, this book is about learning the basics of the photo business, both from a functional point of view and as a discipline, all while maintaining the prime directive: Enjoy the process! Of course, everyone's fun-meter is different, so it's not always easy to say when something stops being fun. But, I think for the most part, the average person who can take good pictures can accomplish quite a bit without feeling like they're running a major corporation.

I'll begin by establishing basic business constructs, and dealing with taxes and other legal necessities. Then, I'll outline basics like equipment needs (and non-needs), managing the pictures you take after you take them, making and selling prints, as well as selling into different markets. Lastly, I'll talk about the nature of running a photo business on the web. Whether you're shooting new material or managing an existing base of images you've shot over time, it's critical to build efficiency into your business, which is the main underlying theme of all these chapters.

Owning your own photo business requires doing a lot of tasks that, if you aren't careful, can be overwhelming. Many photo businesses have collapsed under their own weight, simply because people over-extend themselves in trying to support a sales effort that requires too much of their own time. Postcards and calendars are good examples. People often think it's a no-brainer to take a bunch of cards to a local gift shop and wait till the sales roll in. But it's not that simple, and this very logic often causes people to end up feeling that they have to back away from their business goals.

Other aspects of the photography business are also covered here, such as the hard-to-nail-down problem of pricing products and services, setting up an Internet site, and selling at art fairs and cafés. This is by no means a comprehensive list of everything you can do to make money with your photography, but rather simply some of the more common options that, if addressed effectively, can set you up for many other photo-related business ventures.

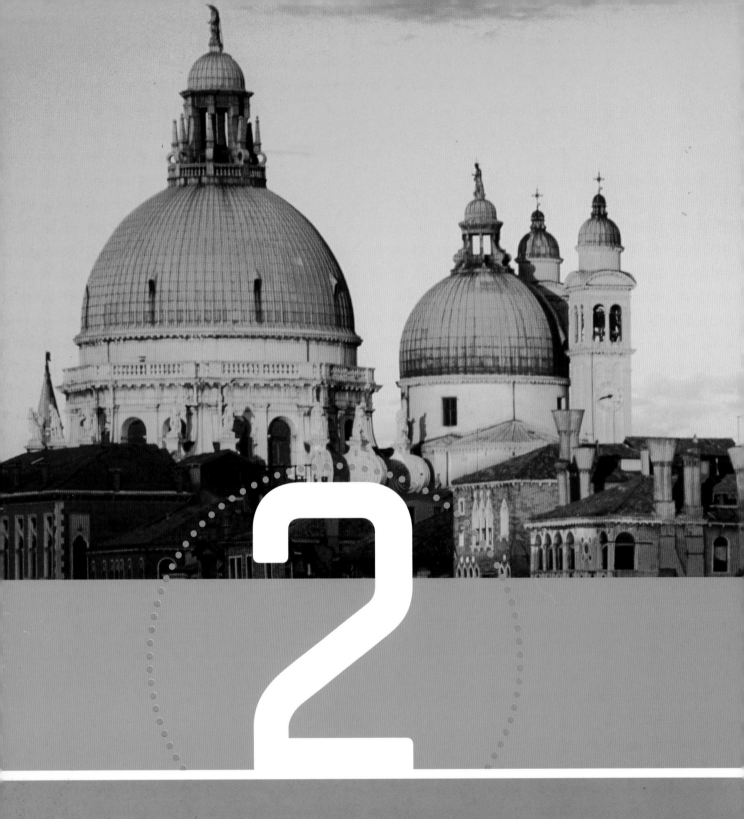

2

STARTING A

PHOTOGRAPHY BUSINESS

starting a photography business

However you envision your future in photography, if you're going to make money at it, it is likely you will own your business. That's right, you're going to be an independent entrepreneur, where you set your own hours, be your own boss, and watch TV late into the night as you clip your toenails. And if you think that sounds fun, just wait—now comes the really fun part: doing your taxes, writing contracts, collecting money from clients, paying your bills, and dealing with attorneys (yours and others). The good news is that I'm not going to get into any of that here. However, where I can be of service is to help you understand the principles behind these things, clear up common misunderstandings, and put you on the right track. On the bright side, this isn't all that hard. Running a business is sort of like riding a bike: Once you learn, you wonder what the fuss was about.

de-myth-defying the photo business

First things first: Despite many Internet rumors, you do not need a permit or license of any kind to qualify as a "professional photographer." Selling photographs or photography services requires nothing more than your desire to do so. The only thing that really matters is how you intend to have your income and expenses affect your tax returns, and that's where the IRS comes in. The Internal Revenue Service has only one interest: whether you are properly paying (or not paying) your taxes.

The IRS and other legal entities use certain metrics to determine whether you're a bona fide business, just an enthusiastic hobbyist, or possibly even a criminal trying to evade taxes. Assuming you're not a criminal, the greatest concern you should have about the IRS is whether or not they determine that you only have a hobby, as opposed to a business (in which case your expenses would not be tax-deductible). You might even have a secondary source of income and also have a photography business. As long as it's a legitimate business and not just a hobby, you can still legally claim tax deductions for business-related expenses.

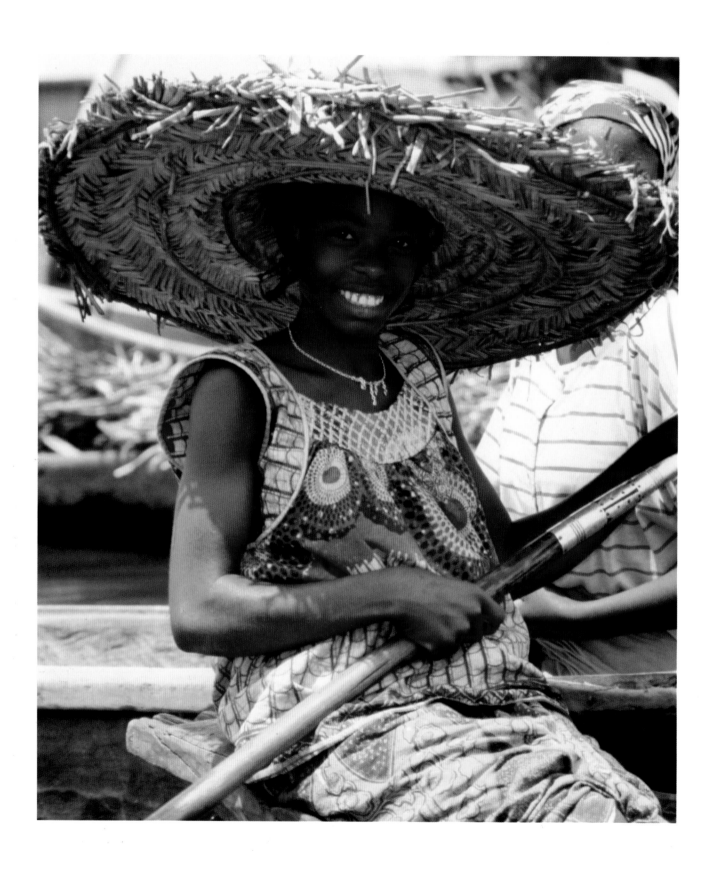

There's nothing wrong with having a photography business while you have other income; the IRS just wants to make sure you're not lying about your motives and inappropriately deducting expenses that are not business-related. When determining whether or not you have a business or a hobby, the IRS generally looks for the following:

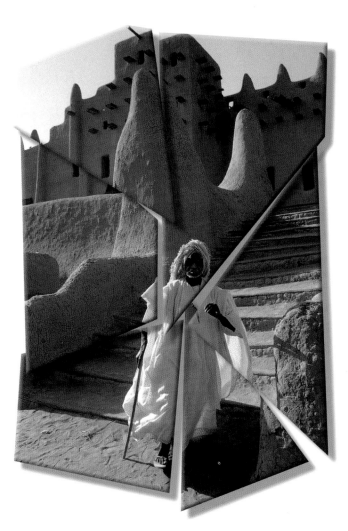

Receipts: This almost goes without saying, but it's important to know that it's not just having receipts that matter. The IRS looks for patterns of behavior. Are you consistent in what you deduct? Are you thorough in your accounting? Is there a consistent correlation between the kinds of things you deduct and the income you declare? For example, if you're deducting expenses associated with trips to Hawaii, but your "photo-related income" is only from wedding assignments in your hometown of Tulsa, Oklahoma, the IRS might send some people over to ask you a few questions.

Separate personal and business travel expenses: Again, it's all about patterns of behavior. Documenting car travel, for example, is always what people hate. If you're going to deduct your car and its expenses, you need to log your mileage at the start and end of each business-related errand, and save receipts for gasoline, tolls, and parking to demonstrate a correlation between expense activity and income activity.

The right tax returns: When you collect your receipts for the year and total up your income, you need to summarize all this to the IRS. Depending on the type of business you have, attach an appropriate schedule to your personal tax returns. Many photographers consider themselves "sole proprietors," which requires filing a Schedule C along with tax returns. This does not change your tax obligations in any way—you still pay taxes on income (and deduct expenses). It's just that this formality separates your business dealings from your personal ones.

Incorporation: You might consider incorporating your business to further establish it as a separate entity. This is the most secure way of protecting yourself from the IRS determining that your business is a hobby, though it's not foolproof (since cheaters are known to use this method as well). Incorporation involves more paperwork and other administration overhead, but there are many other benefits to incorporation, which may include tax savings and legal protections. So, there's a tradeoff, and although incorporating is not for everyone, it's worth looking into if you're serious about aggressively pursuing your business.

copyright your images

Don't forget to copyright your images by registering them with the U.S. Copyright Office. If you are going to license your photos for others to use, like magazines, brochures, ads, or any other commercial use (including fine art sales), this is extremely important. What's more, it's insanely simple. Download and print the "Short Form VA," fill out this one page (8 items), and send it in along with a check for $30 and a CD of your photographs. (Obviously, these would be digital images, so scan your film if that's what you're using.) Submitted images can be low res (low resolution), and you can/should register as much as you can. One can put thousands of small thumbnail images on a single CD-ROM. As for size, as long as the image is legible and can be easily compared with a potential "violation" (in a judge's eyes), that's fine. If it's so small that the judge

might say, "I can see that they might be the same, but they may also be different images," then that's too small. (I use images that are 250 pixels in the long dimension.)

Whether or not you've copyrighted your images has no bearing on the fact that your images belong to you. However, having an image copyrighted makes it easier to collect high penalties if someone steals it and uses it without your permission.

You take a picture, you own it, but that doesn't imply that you can use the image in any way you like. You may still have to obtain rights. This brings us to the subject of model releases.

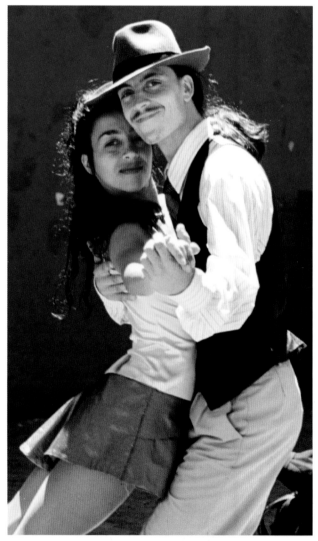

model releases

Let's say you're at your kid's soccer match and you take pictures of the game. You include the players, other parents, other people at the event and so on. You tell everyone that you're going to put the photos online so they can see them, share them, or even buy prints from you. Maybe a newspaper wants to buy some of the images so they can put them in the paper. You might even give some to the school so they can put them on their website, or in the school newsletter. Perhaps some are so good that you want to make big prints and sell them in the local gift shop. It all seems so easy and simple until someone tells you that you can't do these things unless the people in the photos sign releases allowing you to use their pictures.

This and other virtually identical scenarios are the most common kinds of situations people run into. Whether it's a school game, a music concert, an amusement park, or party at work, the circumstances may vary, but they all necessitate answering one big question: "Under what conditions do you actually need to get a release before using pictures?"

Model Release

In exchange for consideration received, I hereby give _____
permission to use my photographic likeness in all forms and media, and to alter it without restriction. I
understand that no additional payment is due to me, and I hereby release the photographer and his/her legal
representatives and assigns from all claims and liability relating to this usage.

Name: _____

Address:

Phone: _____

Email: _____

Signature: _____

Date: _____

If Model is under 18: I, _____, am the parent/legal guardian
of the individual named above, I have read this release and approve of its terms.

Name: _____

Signature: _____

Date: _____

This is probably the most misunderstood issue in the photography world, and the result of this is a lot of misinformation. It's a big subject — one that cannot be covered thoroughly in this book — but I can get you started on the right foot with some very important basic facts.

Taking someone's picture is always legal: There are no laws prohibiting taking the picture, provided you're not breaking other laws to do so (like breaking into a home, planting a hidden camera on private property without notice, or forcing someone against their will, etc.). It's only the use of a photo that may be under restriction, but no one but the subject of the photo can file a complaint. In other words, the government isn't going to go after you just because you are using a photo that hasn't been released. In day-to-day situations, this isn't a problem. The issue only comes up when one of two things happens: money is involved, or someone gets upset (usually out of an irrational fear of misrepresentation, or sometimes when children are involved). Does that mean that you should always get a release for every photo you take to avoid conflict? It would seem so, but this may also stir the hornet's nest, mostly because you plant fears into people that would have never been concerned in the first place. We'll get into that a little later.

If you can't see who it is, you don't need a release: The reason for this is that anyone can "claim" to be an unidentifiable person in a photo, but that doesn't mean they have a case against you. A judge will make that determination, and if the image is unclear, there's no case.

Not every use of an image requires a release: The conditions upon which a release is needed (or not) are the basis for many a barroom brawl. The most common scenarios are easiest to describe. For example, even if you can clearly identify the person or thing in the photo, you can use the image without a release if it is used in the context of news, editorial comments, satire, or (usually) art. So, if you sell a photo of kids playing soccer to the local newspaper to use for a story about sports at school, you don't need a release. That you were paid for the photo has nothing to do with it. News (and the other forms of expression listed above) are constitutionally protected by the First Amendment. We call this editorial use. And while the

newspaper example is a clear one, an example that isn't as intuitive is that of tabloid newspapers. In these publications, you often see rather unflattering pictures of celebrities coupled with headlines that speak about their evil twin alien sister from outer space who is eating the world's Elvis impersonators. These are usually legal because, sadly, it's considered "editorial." (Actually, it's more often considered satire.) On the other hand, you wouldn't see a photo of Elle McPherson in an ad for Viagra unless she signed a model release (in exchange for a lot of money). This would be considered a commercial use because it's promoting a product. Without a release, she could sue the blue coating right off that little pill.

This isn't just about law, it's about people first: As you might guess, in the examples above, lines often blur between "freedom of expression" and "commercial use." There are some cases where it's both, and this is where conflicts start. Don't just assume you're safe because you believe you have the right to use a photo in a certain scenario. If someone objects, you'll have to deal with it (even if you're right), and that can cause more trouble than it's worth. Your options may be limited if you do not have a release.

A model release is nothing more than an agreement: There are no government sanctioned forms or applications, and it doesn't need to be notarized. Even an informal agreement suffices. What makes it legally binding, though, is the fact that it's been written down and signed by the subject of the photograph. As the example release on page 31 illustrates, the agreement can be as brief as a few lines. However, you may notice that this example is pretty sweeping in the rights of usage. Most everyday people wouldn't have a problem with this, but highly paid models with very long legs tend to have similarly long and expensive contracts that act as model releases. Unless these contracts are signed, they won't permit photos of them to be used. You aren't likely to run into this, but I bring it up as a point of reference.

Commercial use vs. private use: If someone paid you to take portraits of their kids, this would trigger the need for a release if you were going to use the image in a commercial context. If you only plan to supply your clients with the pictures of themselves, no release is necessary—the pictures are for private use. Similarly, if you're going to shoot homes for a realtor that has the right to sell someone's property, you don't need to get a release from them unless you plan on using the pictures in another context. You can open up a photo studio in the mall and take people's portraits all day without needing to get a release from anyone. However, if you want to use any of those portraits in the studio itself to show examples of the kinds of portraits you take, you need to get a release from whoever it is. Why? Because this use of the image is a commercial form of promotion for your services.

loose ends

here are some quick tips to remember

Fair use: In the case of some subjects, because of their prominence, it's generally accepted that the common person is going to take pictures of them. For such conditions, there is a term called "fair use." For example, if I wanted to take a picture demonstrating a crowd of people walking down 5th Avenue in New York City to promote a new perfume called, "Essence of 5th Avenue," I could use the photograph on the opposite page even though there are identifiable buildings and perhaps even people. This is a form of fair use, and is protected. The same often applies to national landmarks, parks, or other commonly seen icons. Again, there are exceptions, like buildings that are pri-

vately owned, such as the Transamerica building in San Francisco. Even though it is a commonly seen icon, the owners trademarked the the building itself and license it for vast sums of money. (They obviously can't trademark someone else's image, but the use of a trademarked icon in that image requires a license to do so.) Granted, they don't go after small, frivolous uses, but this is entirely at their discretion.

Property releases: A "model release" applies specifically to people, but for buildings or real estate, you need a "property release." Such releases are necessary when using photos of a private home, or even a public business, where the use of that image would be for promotion or advertising. The issue of "identifiability" is still in play here; in general, structures tend to be unique enough that it's easy to tell them apart, but because of fair use, identifiability can be trumped by non-commercial use. For example, one can use a photo of the town square on the cover of a local phone book because it's not a commercial product for sale.

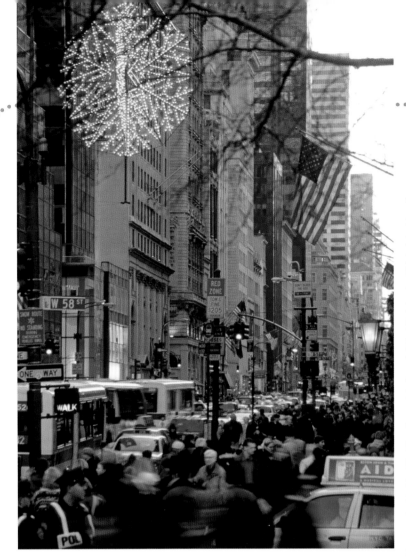

You own your photos: Even if you don't have a model release and you cannot "use" the picture, you still own it. You are not required to forfeit your media (prints, film, digital copies) just because someone did not authorize you to take their photo or use photos you already took. However, owning a photo does not give you an implicit right to use it. This often confuses people who purchase rare photos of celebrities, like the Beatles. You can buy rare negatives, but this doesn't mean you can start a new business selling Beatles' posters.

"A verbal agreement is as good as the paper it's written on.": That's actually a quote from Samuel Goldwyn, who, as a pioneer in the early motion picture industry, had to deal with such issues all the time. Whatever you agree to, even with the best intentions, it's not worth anything unless it's written down. So, get a release in writing. It's always better to be safe than sorry.

Art, books, exhibitions, presentations, etc.: For the most part (in the USA), artistic exhibitions (and publications) are considered editorial and are usually protected by the First Amendment. So, you could publish your pictures of the soccer players at school in an art book, or display them in a gallery. Again, the pragmatic side is that not everyone knows this, and if you use an image of someone who doesn't know about it ahead of time—especially if it includes their kids—you're likely to be in for a big fight. My advice is to inform your subjects of your intentions. Keep in mind that the cover of a book is often considered commercial in nature because it's the part that "sells the book." The issue gets fuzzier still when you get to posters and postcards. If it looks like advertising or a salable product, it's going to be a problem. Rights of publicity are generally created by statute, which is defined on a state-by-state basis.

Pet releases: Like with humans, the issue with pets is also that of identifiability. People are easily identified—not just because you can see their faces, but because we're the same species and we're wired to see the uniqueness of each other. The same cannot be said of pets; more specifically, we can't always see the uniqueness of different animals of a similar breed. Owners may vigorously differ with that opinion, which is where the fuzziness comes in. If a pet is easily identifiable (i.e., if an impartial person looking at the photo would easily match it with a specific animal), then yes, you need a release. But this is rarer than the pet's owner may think. Someone may easily be able to pick his or her own dog out of a lineup of similar dogs in a photo montage, but the question is whether an impartial human can pick it out. The final arbiter in a lawsuit would likely make a determination based on other circumstances where a release was necessary, rather than on the identifiability of a given pet by its owner.

Religious or political uses: Religious institutions consider their programs "educational," but the government—and by extension, the legal system—does not. At least not when it comes to whether images of people require a release. Consider how you would feel if your image was used in a religious textbook that promoted an ideology you don't believe in. While the USA allows freedom to express religious views, using images of people in the same context would strongly imply that they subscribe to those views, which may not be the case. The same can be said of political image use. The subject of the photo may or may not subscribe to the politics associated with the image use, so a release would be required.

Photos on the web: Private individuals can put photos on the web without a model release. Where it gets sticky for pro photographers is whether the photos can be construed as being a form of advertisement. One way to protect yourself is by having your website present an editorial side as well, full of non-commercial content. You can provide information and resources that are educational or satirical in nature, or use other forms of commentary that sit squarely on the side of the First Amendment. Knowing the issues discussed in this chapter will help guide you in how to deal with your emerging photo business.

the risk/reward analysis

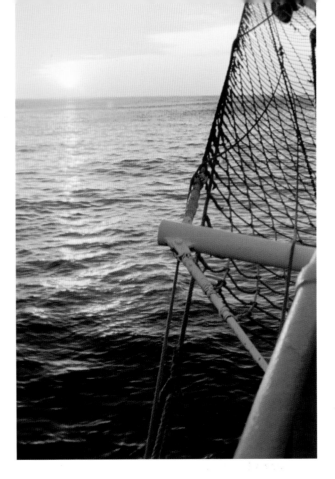

We always want to play by the book and do things right. One could say that you should always try to get a release because it never hurts. But, the pragmatic reality is that most of the time this is not very easy. If you're on vacation, shooting many things or people at once, or just in a social context where the environment makes it too difficult (if not inappropriate) to get releases, then you are likely to end up with unreleased images. What can you do with them? What's your risk?

In brief, it goes like this: People sue either because there's a perception of easy money, or because they're just upset about how an image was (or will be) used. If it's not about money, the solution is relatively easy: Talk to them. Allaying people's fears about how their images may be used eliminates 90% of the problem right there. You may still need to pay people for a release—and you should—but that typically isn't a lot of money. (A few dollars is typical for a street-grab-shot, although conditions and luck may vary.)

Using unreleased images has various degrees of risk. People or companies with lots of money always have to be careful about what they do when it comes to the public because of their susceptibility to lawsuits. Even baseless lawsuits are costly to defend, and unscrupulous people are known to go after large media companies for photo usages, even though 99% of these claims are without merit. The only real defense against this is to get releases for images you plan to use, even if the use doesn't require one. In a sense, your own risk is somewhat guided by this fact: If you never get releases for your photos, chances are you're not going to have many highly paid sales, so your risk will be low. Or, if you're just selling for editorial use, you don't need a release anyway and you needn't worry about it. (There's plenty of good money in editorial use of images.)

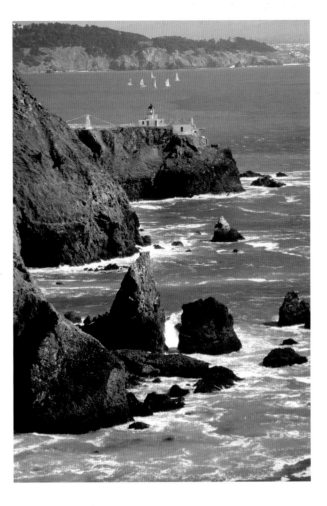

Just be sure to be selective with your use of unreleased images. For example, consider that you have an opportunity to license a photo of a kid kicking a soccer ball to a local sporting supply store who uses it in a local newspaper advertising insert. If this is a local boy and a local store, chances are it will be seen by the subject of your photo. However, if you sell the photo to a store on the other side of the country who uses it in their home paper, chances are pretty slim that anyone who recognizes you or the subject will see it. Does that mean you don't need a release? As is always the case, if you can get it, get it. But, as I mentioned, getting releases is not always as easy or as practical as it seems. The decision to pass up sale opportunities becomes the point of question.

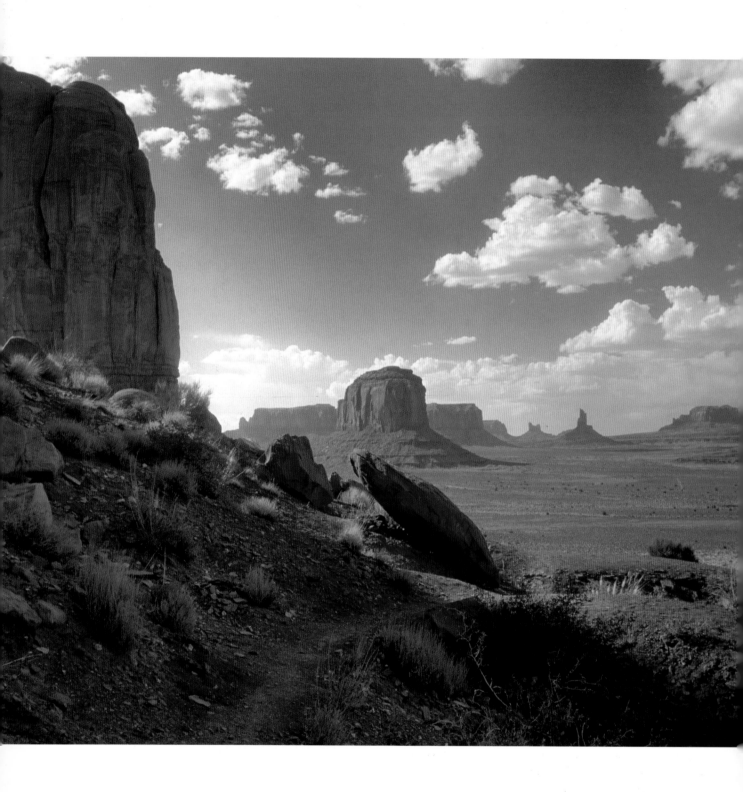

Regarding the issue of compensation, this is a deep subject, and it's not easy to cover all the various scenarios. While it may not happen all the time, you can be assured that there will be times when people will want some form of compensation in exchange for signing a release. For example, if you asked the soccer kid's parents for a release, they may want to get paid for it. You might not know how much to pay them, and they certainly don't know, so it's a matter of negotiation. Meeting people's expectations is random and unpredictable. If you're only going to get $100 for the photo in the first place, and they expect $1000 because they have unrealistic impressions of the modeling world, you're out of luck. Weigh all the factors—the location of the photo subject, where and how the image is used, whether it's even feasible to get a release, what the pay is, what your risk will be—then rely on your own sense of pragmatism.

Lastly, understand that in the real world, most companies who license pictures of people for magazine ads or billboards almost always use professional models and hire specific photographers to shoot them under controlled conditions. It's very rare for a company to license an image from an unknown photographer who happened to get a great looking lucky shot of a soccer game (or anything else). Even highly paid professional photographers who do this for a living present portfolios of possible images to clothing, cosmetic, and sporting goods companies, but never sell those pictures. They're hired to shoot a new series from scratch under controlled conditions with released models. So, if you have visions of selling pictures to big companies because of great shots you took, and are wondering whether you should have a release, keep all this in mind. They may love your pictures and hire you to do a whole new shoot, but you're unlikely to sell a winning grab-shot picture you took on vacation to Levi's for a new ad campaign.

This is not to suggest that there's no money in the photo business unless you do these high-profile shoots. There is! Those high-profile opportunities, and the photographers who shoot them, are few by comparison to the entire market. You can make a really good income by selling photos in infinitely more contexts. Some may need releases, and others will not. Now that you have the overview of the subject, you can do further research on how and when releases come into play, and to what degree you should worry about it. (Go to www.danheller.com/model-release.html for a much longer article on the subject that gets into specific details on usages.)

summary

Starting a photography business should be thought of as an evolving process. You don't just "set up shop," complete with forms and business matters, before you take your first picture or make your first sale. Instead, you often delay activities until you really need to do them. Whether it's incorporating yourself as a new business entity, getting business cards, putting up your first website, or asking someone to sign a model release, the growth of your business is a "from the bottom up" process. Trying to forecast what you will need before you need it might cause you to do a lot of unnecessary and costly work, all for nothing. Worse, you may have to do it all over again once you have a tangible need for it. The best thing to do is to just start shooting, then do everything else on an as-needed basis.

3

PHOTOGRAPHY GEAR
FOR A PHOTO BUSINESS

Photo © Lowepro USA

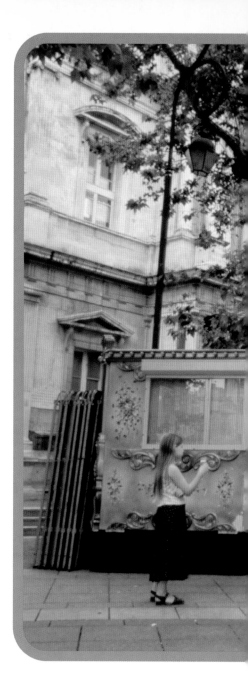

photography gear
for a photo business

When I got serious about making photography a real business, I felt I needed to migrate from amateur equipment to pro-level stuff. In the middle of doing extensive research, I got a call from a client who asked me to shoot a cycling trip for them. I didn't have time to buy the expensive "pro" gear, so I was worried that I was ill equipped for the job. To my surprise, the pictures came out fine and I still sell many of them today. Now, years later, I have costly pro gear that I never thought I'd have, let alone use. But, the reasons for upgrading aren't what I would have thought back then, either. The point is, don't assume you need the best equipment to be a pro; you just need to decide what's most appropriate for your type of business.

Obviously, there are many different kinds of photo businesses, and my intent is not to tell you what to buy; it's to help you think about the issues that actually matter (and those that don't) so you can make better purchasing decisions. As with all products, there are many models and brands, most of which may be suitable for your needs, so don't assume there is only one right answer for you. As long as you know why you may or may not need something, you'll feel confident in the decisions you make.

camera bodies

So, back to my story: There I was, looking to buy a new camera body for the purpose of building my new photo career. In the extensive research that I was doing, I found a great little understated quip that someone uttered on a photo discussion board: "Camera bodies don't affect image quality; lenses and film do."

This cleared the field of many choices right off the bat. Instead of looking for camera bodies, I realized I should be looking at lenses first. However, in digital photography, the "film" is now part of the camera body, so the body has become important again. While there are clearly many quality film-based systems, the context for professional photography discussion today is more about digital. So, let's begin with a preliminary discussion on what's important in digital cameras and why.

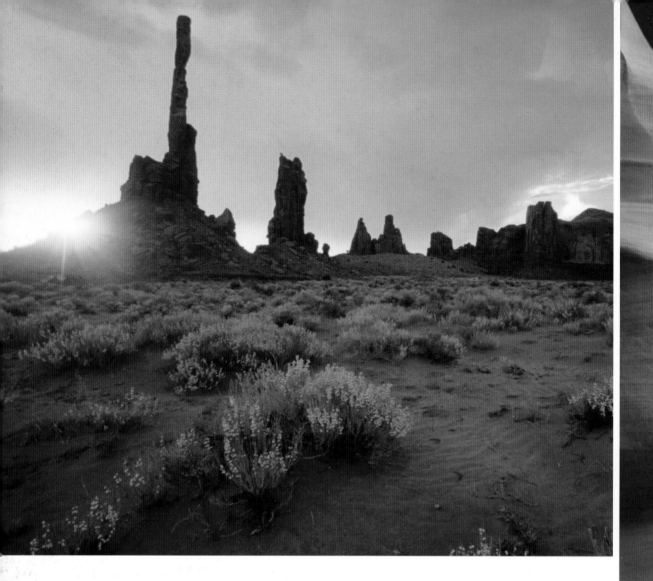

resolution and dynamic range

The most important part of a digital camera is its image sensor, which can be evaluated for resolution and dynamic range. Resolution is the total number of pixels, and the dynamic range is the sensor's sensitivity to light (i.e., the detail it sees before it loses information due an excess or absence of light). For example, if you take a picture of a scene with both sunlit and shadow areas, the important question is how much detail you can see across the range of brightness. Cameras perform very differently from one another in this regard, despite what you may see in photo magazines. In most print ads, you see pictures of pretty models under studio lights. These photos claim to illustrate dynamic range by showing bright colors mixed with dark ones. The implication is that the camera can pick up details across the entire spectrum, but this is deceptive. The discerning viewer knows not to confuse light range with color range. These pictures are misleading because light intensity is not being tested, just the color. Any device can produce those kinds of images because of the nature of the conditions under which they were shot. The

real test of dynamic range, however, is how much detail can be seen in all parts of a picture, as in the images above.

The range of light that a digital sensor (or film) can capture is called latitude. The broader the range of latitude, the more detail it can pick up in extreme highlight or shadow areas. While all digital cameras have some moderately acceptable degree of latitude, here's a case where the old cliché applies: "You get what you pay for." Yes, the more expensive digital SLRs (DSLRs) really do have higher resolution and can capture a broader range of light than their less-expensive counterparts. I can't recommend any here because the technology is evolving so fast that whatever I mention may well be obsolete by the time you read this. So, read up on product reviews in reputable photo magazines and websites to see what cameras are currently hot and why.

With that information in hand, use this piece of smart business sense: Don't oversimplify. If you're going to buy a new digital camera or migrate to digital from film, choosing what's right for you requires understanding your business needs. If you're only shooting school portraits, you can easily get away with low-end equipment. Wedding photographers can use a good mid-range camera, but sports, travel, and advertising photographers will probably need the highest-end cameras available. Can you figure out why? The factors that place each of these examples into their respective categories will be the factors that you need to understand before choosing which digital camera is right for you.

Let's apply what we just reviewed about resolution and dynamic range. School portraits rarely require prints over 11 x 14 inches (approximately an A3 print size), which just about any low-end digital camera can produce. Similarly, the lighting conditions are fixed (because you have studio lights), which a low-end camera can easily handle. In the case of weddings, you may make larger prints—often as large as 20 x 30 inches (approximately an A1 print size)—but you also have a more dramatic range of shooting conditions (sunsets, cloud cover, etc.). These conditions, however, are often leveled out by the constant use of flash (and any other additional lighting equipment that these controlled environments can accommodate). Most mid-range cameras can easily handle such situations.

In the categories of sports, travel, and advertising photography on the other hand, there are many cases where extremely high-resolution images are necessary, as in printing for billboard use, for example. Similarly, extensive dynamic range is required due to the unusual and unpredictable shooting conditions of these photo categories. What's more, other more advanced features may be important, such as high frame-per-second shooting speeds and weather resistance, both of which are usually only available in the highest-end cameras. These are two of the "unexpected" reasons I referred to in the beginning of the chapter for why I was forced into higher-end gear, myself.

Photo © Canon, Inc.

going digital The wisest business decision should not be based so much on buying the "best" digital camera as on buying the "right" digital camera. Because I am a travel photographer, my need for resolution and dynamic range forced me to stay with film until very recently, when digital sensors could rival what I could get from a high-resolution scan of a quality slide. And again, it's not just about resolution; there are many other valuable features, not the least of which is a broad ISO range with minimal noise.

Make no mistake, my business still runs successfully with my huge library of film stock, much of which has been scanned. One shouldn't presume that you can't run a successful photo business on film. You can, as long as you convert your film to a digital format for your business purposes. Even then, it's still more economically (and technically) beneficial to migrate to an appropriately configured digital camera. And yet, those who shoot film are familiar with its benefits—their clients may require it, or the photographer may still make prints in the darkroom, and there are certainly other artistic justifications as well. Again, you need to determine what's right for you.

medium format Medium format cameras have been part of the professional photography world for decades, essentially for one reason: The size of the film is more than twice as large as 35mm film, yielding exceptionally sharp and brilliant pictures. There's no question that the thrill of getting that film on the light table is incomparable; anyone can feel like a pro with a medium format camera. The usefulness of these cameras, however, has waned since the quality and resolution of high-end 35mm digital cameras surpassed that of medium format film. While you can buy digital backs for medium format cameras, their enormous cost doesn't really justify the marginally better images they produce. Therefore, the use of this format is limited to smaller, specialized fields of photography.

This doesn't mean that medium format cameras are useless, or that they will disappear from the world pf photography, but the argument in favor of them is a similar one to that of film: If you're already invested in it, you know and understand the system, and if you've done it for years, you might as well stick with it. If you're buying a new system for a new business, however, you'll eventually find that the finances point towards a digital SLR.

lenses

There are so many different kinds of lenses to choose from—one could write an entire book just listing them all! To understand what kind of lenses are most appropriate for your creative and/or business needs, we need to address a subject that will eliminate 90% of the confusion. That subject is blurry pictures from hand-shake. We've all experienced it, and some great photos are lost because of this simple, but annoying problem. The reason is similarly simple; the longer the focal length of the lens, the more susceptible it is to shaking when you take the picture. The rule of thumb is that the reciprocal of the shutter speed needs to be as fast as the lens is long. So, a 500mm lens needs a shutter speed of at least 1/500 second. A 200mm lens needs a shutter speed of at least 1/250 second (cameras don't shoot at "1/200"). Even a short 50mm lens needs a shutter speed of at least 1/60 second, a speed that is still susceptible to hand-shake for many photographers. This may not be an issue in bright, sunny, outdoor situations, but in the evening, or indoors, you've got problems. To deal with these situations, you are forced into one of the following choices:

Photo © Canon, Inc.

choice 2.

Use a tripod: Tripods are great for producing steady shots, but they're often impractical for street shooting, or scenarios where you've got to move around on foot.

choice 3.

Use a very bright flash: On-camera flashes are great as a "fill" to bring light to shadows under hats and to temper harsh sunlight, but they are dreadful when used as the main light source in evening or indoor photography. When shooting for business purposes, the improper use of flash can create an unnatural appearance that makes pictures look amateurish, limiting their sales potential.

choice 1.

Use a "faster" lens: "Fast" lenses are called this because they allow you to shoot at faster shutter speeds. They have wider apertures, like f/2.8 or f/1.4, which allow them to accomplish this. The tradeoff is, of course, that the wider your aperture, the more limited your depth of field will be. If the scene isn't bright enough, you may have to "open up" the lens so wide that your subject may end up out of focus unless your focus is dead-on. Get it wrong, and you're not much better off than if the photo was blurred from hand-shake.

choice 4.

Use faster film, or set a higher digital ISO rating: Both of these options degrade photo quality substantially. The best pictures are those shot at very low ISO settings (film or digital) because the grain is smoother and the colors are more realistic and vibrant.

choice 5.

Image Stabilization Lenses: The best solution to this common problem is image stabilization (IS) technology. This is a system embedded into some lenses and camera bodies that uses a gyroscopic element that spins in a direction that counters the destabilizing movement. Using IS, I am able to handhold at shutter speeds as slow as 1/8 second and still get sharp pictures in low-light conditions while retaining a low ISO setting. When you calculate that 30-40% of the pictures that would otherwise by ruined by unintended hand-shake are now saved, the sale of any one of those pictures offsets the incremental cost of an IS lens.

Of course, IS does not guarantee perfectly still images. The system does "drift," much like a spinning top gyrates to keep from falling. This means that you can still get blurry pictures if you use too long of an exposure. Even so, IS keeps you ahead of the game. On the other hand, short lenses cannot readily accommodate the gyroscopic elements necessary for the feature to work. But, that's okay. Shorter lenses are less susceptible to the problem anyway.

Canon developed the first image stabilization technology in 1990, and Nikon developed their own version in 2004. A few other camera makers are jumping on the bandwagon as well, albeit more slowly. The current trend is to move the stabilization to the camera body itself. Suffice it to say that it will eventually be found everywhere, but like anything else, quality may vary considerably.

If you're thinking that there are innumerably more factors involved in lens quality that should be considered beyond IS, you're absolutely right. Image quality is highly dependent on glass quality and other lens construction, but most of the top-name brands have high-quality glass suitable for most photo business needs.

angles they're used to. The other alternative manufacturers have presented (albeit a much more expensive one at present) is digital camera bodies with full-frame 35mm sensors. With these high-end cameras, you can expect your lenses to perform at their specified focal lengths without worrying about the zoom factor. However, as we move on to discuss lens options in this chapter, keep in mind that if you have a digital SLR with a sensor that's smaller than 35mm, you'll need to multiply all focal lengths by the zoom factor to determine the effective capabilities of any lens your considering. (The zoom factor is usually 1.6, but be sure to check with your camera's manufacturer to determine exactly what the zoom factor is for your particular model.)

mid-range focal lengths

I'll start with mid-range lenses because they're the most commonly used for situations like day-to-day snapshots, candid people pictures, landscapes, dogs, or anything else from a normal viewing perspective. Focal ranges usually fall between 28mm and 150mm, though many lenses vary (some adding more range on the wider end and/or the longer end). In fact, some lens manufacturers make lenses that zoom from 24-300mm, covering both the wide-angle and telephoto categories.

It should be noted that there is a tradeoff with ultra-dynamic range lenses; the wider the range, the lower the image quality on the extremes. The narrower the range, the better the quality. "Fixed-focal-length" lenses (that don't zoom at all) are the sharpest, and yield the best quality pictures. But they are less versatile and hence, less practical for many photographers—having to carry more lenses just to get the broader focal range you need can be a real pain.

The objective is to find a focal range that's both versatile enough to retain usefulness and constructed well enough to produce good image quality. For me, my main workhorse lens in this category is the Canon EF 28-135mm IS. It seems to be a reasonable balance of these needs, and it has the IS component that I value as necessary to my work. On the other hand, because its image quality may not meet certain commercial needs, I also have the Canon EF 24–70 f/2.8L. Here, the range is more limited and it doesn't have IS technology, but it's sharpness makes it more appropriate for certain controlled situations (portraits, weddings, pets, products, food, etc.). Many other brands offer similar ranges, but product quality (and subsequently price) varies considerably.

the zoom factor

Before trying to determine exactly which lenses are appropriate for your needs, there's one more thing to remember: The sensors in most digital cameras are smaller than a 35mm film frame. This, in effect, causes a "zoom factor." In other words, when a lens is placed on a digital camera with a smaller sensor size, it will yield a photo that looks "zoomed in" compared to a shot taken with the same lens using a full-frame 35mm camera. Most digital cameras have a 1.6x zoom factor when compared to a 35mm film frame, so a traditional wide-angle 20mm lens, for example, will result in a photo that looks like it was shot at a focal length of 32mm. This can be extremely confusing and troubling for those who are expecting to be able to use the widest angle that their lens allows.

This is an ongoing issue for camera manufacturers. They have been forced to create super-wide lenses designed specifically for use with digital cameras in order to be able to offer photographers the traditional wide

telephoto lenses

Telephoto lenses are best known for close-ups of people or wildlife, but they're also great for landscapes. Long lenses usually start at around 100mm and can go on and on. The photo shown here with houseboats in Sausalito and the city of San Francisco in the background was shot with a 400mm f/2.8 IS lens with a 2x extender added on, which equates to 800mm. It's an impressive shot that yields good returns in my business. Within a few days of putting it online, I sold several prints and licensed it to various companies for a variety of uses. All sounds great, right? Now the bad news: The lens costs over $8,000 and it weighs over fifteen pounds once you factor in its carrying case. What's more, it requires a very heavy and rugged tripod, which costs a fair amount, too. These aren't things you carry in a picnic basket, or expect to get as a birthday present, but when your business depends on it, you get it.

mirror lenses

Since it's not always practical to spend money on (or even use) a big, expensive telephoto lens, you can downshift to less-expensive lenses that are lighter and have smaller maximum apertures. For example, a 500mm f/8 mirror lens weighs in at only 13 ounces, making it perfect for carrying with you at all times. Slightly more expensive is the 600mm f/8 mirror lens, weighing in at 29 ounces. Both lenses are fixed at f/8, and do not autofocus. The super-long 500mm and 600mm lengths mean that your image is going to jiggle like Jell-O on a roller coaster when the picture is taken, so you need to mount the camera on a tripod. What's more, you'll also need to trigger the shutter remotely, or use your camera's self-timer to delay the shutter release because the moment you touch the camera, the image will jiggle. You'll need to allow it to settle before the shutter releases. And even then you're not assured of stillness.

My photo of Sausalito and the Golden Gate Bridge, shown above, required a shutter speed of 1/250 second, which is far too slow to try to handhold the camera with a constant f/8 aperture. (Many failed attempts taught me this lesson.)

So, can a cheap mirror lens compare with my $8000 behemoth? Not even close. Not a single attempt at reproducing the San Francisco photo was sharp or attractive enough to bother keeping. On the other hand, these lower-end lenses are useful because they are inexpensive and not bulky. In short, they're fine for personal use and artistic creativity, and they'd make a perfect gift for the photo-enthusiast in your family.

telephoto zooms

Let's face it, telephoto lenses are most practical and useful when they zoom. But, you can't escape the quality/range compromise—the greater the range of zoom, the lesser the quality. Even so, it is fair to say that the range of tolerance is better at the longer end, though many pros consider a 70-300mm lens to be insufficient for their needs. (I'm included in that group, although my personal favorite lens is still Canon's 100-400 IS.) It is possible to get a broader range and still maintain quality if you're willing to live with certain compromises. For example, Canon's EF 28-300mm IS is a dream come true in every way except for weight and cost. While it takes stunning pictures, its scale-tipping 4.3 pounds make it impractical for most people and, at over $2100, don't expect it to come in the form of a gift. Before I dismiss heavy lenses too quickly though, it should be noted that they're perfect for sports photography. By placing your gear on a monopod, you can alleviate the need to carry it, allowing you to shoot from a stable position while rotating as necessary to follow fast-moving subjects.

wide-angle lenses

For me, my wide-angle lenses compete with my telephoto lenses for usefulness. Because of the shorter focal lengths, hand-shake blur is less of a problem, so there's no need to put image stabilization into this line of lenses. Also, because shorter lenses can have a greater width, you can get apertures of f/2.8 and wider without excessive cost, compared to mid-range or, especially, telephoto lenses. The main issue to concern yourself with when it comes to wide-angle lenses is the aberration of image quality.

I have a Canon EF 16-35mm f/2.8L wide-angle zoom, which is especially good for interior spaces, and even more so from tight corners. It's amazingly sharp, and its lens elements reduce flare better than most lenses I've seen. However, its price tag will be out of range for some. An alternative is the EF 17-40mm f/4, which is half the price, has a smaller maximum aperture, an doesn't use the L series glass that Canon is so well-known for, but it can still provide suitable photos for a moderate or emerging pro. There's nothing unique about Canon in this regard; other manufacturers have comparable products and price ranges that mirror Canon's product line-up. And remember, lens tests of any brand should be researched before purchase.

fisheye lenses

For ultra-wide angles, I use a 15mm fisheye lens and, to a lesser degree, a 14mm f/2.8 aspherical lens (i.e., not fisheye). You can see the results in the image above. I use wide-angle lenses for everything from landscapes, to people, to general street shooting. There is no rule for when to use or not use a wide-angle lens, as that is a creative choice. One thing to note is that, despite the fact that the 14mm should be wider than the 15mm, the fisheye lens actually captures more than the 14mm lens. This is an effect of the distortion of the glass. As a matter of fact, I absolutely love my fisheye lens and carry it with me constantly. Sure, it can bend things out of proportion, but sometimes that's exactly what I want. Fisheye appearance is good for humor, to exaggerate, or for creative control. I license a lot of images shot with my fisheye, so it does provide a very practical and real business use. However, it can also become unwieldy to those unfamiliar with it. It's very easy to try to "get too much" into the scene, making it far too busy. Rules of composition apply here more than ever; make sure that the picture is balanced and has a featured subject or theme or you risk making a dud shot.

digital memory

Digital cameras capture pictures by writing image data onto memory cards. Like film, these cards can only hold a certain amount of information (albeit the capacity of most memory cards is much greater than that of a roll of film). When a memory card is full, you have to clear it or insert a new card before you can continue taking pictures. Therefore, there are several factors you should consider before going out on a shoot.

optimal memory capacity

To evaluate what capacity memory cards you need, there are several questions you need to ask:

What is the resolution of your camera? My 17-megapixel camera records image files that are technically twice as big as those that an eight-megapixel camera would. Each image from my camera can be as large as 15-megabytes. (Note that higher ISO settings consume more memory.)

How many shots should you take when you see something you like? I tend to shoot a lot of frames of a subject I find interesting. I don't just take a snap or two and move on.

Do you review images in the camera as you shoot? I very rarely do this, because the LCD screen consumes battery power, and the process takes a lot of time. What's more, I've found that I can't really trust the details on the LCD; I'd rather edit after I've downloaded the pictures so I can view them in high res on a computer monitor. If you are in doubt, spend time shooting more pictures, not reviewing.

How many cards should you own? I only use two memory cards. One is in my camera at any given time, and the other is being downloaded. I then switch them when the next card fills up. (If you're on the road, however, I recommend you have at least one backup card in case either of your main cards gets damaged.) Cards are expensive, and you don't usually need more than two as long as you have an external disk drive that you can download images to. If you opt not to have a portable drive, you need to have a series of memory cards. You'll have to do the math (price per megabyte) on the cards and drives to figure out which is the less-expensive option. I've tried to track it over the past year, but the volatility of prices and quality products makes it infeasible to pinpoint at this time.

What is your tolerance for interruptions? In the days of film, there was nothing I hated more than finishing a roll and having to stop to change rolls. Those days are over with memory cards, because now I can buy very high capacity cards and shoot most of the day (if not all day) without having to change cards or download pictures more than once. The tradeoff is cost. Higher capacity cards cost more, but those prices are dropping so fast that, eventually, it may not be an issue. If you change cards when you fill one up, the question is how often you want to do that.

It's impractical to make specific recommendations on memory card size because of how quickly technology evolves. When I started writing this book, I used two 1G (one gigabyte) cards, but I have since upgraded to 2G cards, and I now see that the 4G cards are about to drop in price significantly. By the time you read this, it could be that 8-10G cards are the norm. (Incidentally, they've been around for awhile, but at astronomical prices.) So, I'll advise with my usual spiel: Research product reviews on the Internet from reputable sources.

Photo © SmartDisk Corporation.

external storage

When you fill up a memory card, you have to download the photos to some device until you can transfer them to your main computer for digital editing, captioning, and archiving. Obviously, if you can download directly to your computer, do so. However, if you're in the field, whether on a day trip or a multi-month vacation, you'll need to put them on a portable device, such as a laptop or a portable hard drive. If you have a laptop with you, that's probably you're best bet because you will also have image management capabilities. The next best bet is a portable hard drive.

Many people are familiar with data storage devices like the Apple iPod, but these may be inappropriate for digital photography for one primary reason: You need to see that your pictures transferred successfully before deleting them from the memory card. A storage device intended for music playback may have enough storage space, but if it doesn't have an LCD screen with image preview capabilities, it's the wrong product for this use.

Like anything else with digital photography, choices grow and quality progresses in the blink of an eye. Last year, I chose the SmartDisk Flashtrax because of its generous screen size. It also had the disk capacity that I needed, 80G, which allows me to shoot for about six weeks before it's full. (I tend to take long trips.) As much as I like my Flashtrax, the leapfrog nature of technology has already yielded newer devices that may be more attractive to you. Although I personally don't need such features, portable hard drives now include multi-image viewing in the LCD, larger screens, interfacing with other devices (like televisions), wireless transfers, instant CD or DVD creation, and instant print capabilities. Before the end of the decade, you'll be able to make toast, too.

summary

Buying photography gear for your photo business involves two basic steps: determining what exactly you need, then finding the best brands and prices. Fortunately, the latter step is extremely simple thanks to the Internet; product reviews are available online, and the best prices can easily be found using Internet search engines. Determining what you need is more challenging. The goal of this chapter was to help you understand the basic equipment you should consider. Many companies provide excellent products that get the job done, so you should make your choice based on practical, tangible factors such as the weight of the equipment (bodies and lenses vary dramatically in this area), bulk (carrying all that gear can be cumbersome), whether the equipment is user friendly, and general aesthetics (the look and feel of the camera, lens, tripod, etc.).

Never take the advice of just one person, whether their a professional photographer, a photo shop sales person, or a friend. Browse photo-related discussion boards on the net and gather dissenting opinions as well as advocating views. Negative comments may reveal an important perspective you wouldn't otherwise have considered.

4

IMAGE
MANAGEMENT

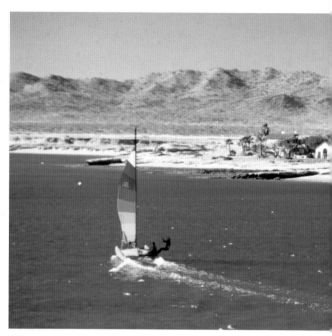

deconstructing image management

Despite this characterization, what really makes back-room photography work unpleasant is not so much the work itself, but the volume of it. Therefore, it's all the more important to be make it quick and efficient so you can get the tedious work out of the way and get back to the fun part. What we're going to cover here is what you do after you take pictures so you can prepare them for sale.

To be comprehensive, we're not just talking about digital photography, even though your final product is a digital image. You may be shooting 100% digitally now, but you might also have a large collection of film-based pictures from days gone by that you want to incorporate. Indeed, over 90% of my images are from my film days, even though I never even see the film anymore. That's right, even before I ever owned a digital camera, I still managed my entire business with digital photos, the result of scanning my film. In fact, after I scan film into digital format, the original slides usually never see the light of day again. The good news is that much the process of dealing with film is remarkably the same as it is with digital, so combining these processes will make everything easier.

image management

Have you ever been to one of those gorgeous five-star hotels with opulent chandeliers, 16th century carpets, and tapestries hanging from the walls? You think to yourself, "I could live here." But then the janitor comes out of the closet door, and you unintentionally glimpse inside and see a dirty, disorganized mess, with unpainted drywall and exposed pipes. The dripping condensation evokes a sickly smell of mold and mildew, so you quickly turn away. And that's when it hits you—it's all a facade.

Welcome to image management, the janitorial closet of the photography business. Like the hotel, you got sucked in by the glamour, taking pictures of European hamlets, ancient architecture, Gothic cathedrals. But before your pictures end up on the cover of those glossy travel magazines, you have to do the dirty work necessary to make it all possible. Come with me behind the steel door that says "Employees Only" so we can discuss how you get those photos from the camera to the client. Luckily, it doesn't smell that bad.

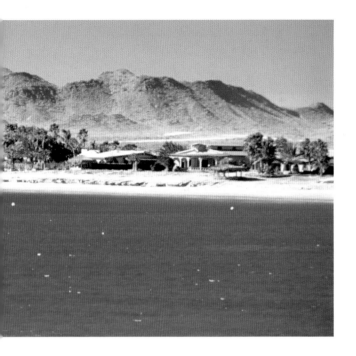

grouping and selecting images

Another process that's specific to film is organizing slides. Once they come back from the lab, I put them on a light table and look at them one by one. Because they're already organized by location, this part of the process involves sub-sorting by subject. With digital images, instead of a light table, I bring up the photos in an "index" format (using Photoshop) and view them in exactly the same arrangement as the physical slides. In both cases, I group like-subject photos together (such as animals, people, buildings, landscapes, art, etc.). For slides, I make separate piles. For digital, I place them in appropriately-named directories (folders). It is also during this process that I throw out pictures I can't use (usually for technical reasons, like bad light, undesirable motion blur, bad facial expression, etc.). One third of the images are tossed out on this pass.

after shootng pictures As you take pictures, you should always document what the picture is, or where you were, so you can prepare it for image management (whether for presentation, archiving, or sales). When shooting film, immediately upon finishing a roll, I write the date, location and subject on the film canister itself. If I return from a big trip and dump 50-100 rolls on the counter of the photo lab, I now know which pictures were which. I then tell the photo lab to label the slides on the slide mounts (see adjacent photo).

This process is even easier when shooting digitally because the camera embeds timestamp information into the image data (along with other shooting info, like camera settings, etc.). I know where each picture was taken simply by sorting images by date and reviewing my itinerary. My digital camera happens to have a recording option so I can record voice memos as to the subject or other helpful information. Another good option is to just take a picture of a sign or literature that you may have available. (Personally, I hate to stop shooting to write anything, so I prefer this option.) Also, since I download photos to a portable device (laptop or portable hard drive), I name the directory (or folder) into which I place each set of pictures. (See pages 56 and 68 for more about portable hard drives.)

This section deals specifically with film. Since most people who are thinking of starting a photo business still have a lot of film, the material covered here is important to discuss. The objective, of course, is to scan film to make a digital version, which is used for the rest of the photo's life, whether for printing, the web, or delivery to clients that license images.

I scan my slides using a 4000 dpi scanner. To give a sense of what a 4000 dpi scan of raw 35mm film is like, this equates to about 5400 pixels in the long dimension, by 3800 pixels in the short dimension. (For a complete discussion on image resolution and dpi, see page 84.) Because images are your assets, it never makes sense to scan images at a resolution lower than what the scanner is capable of. Similarly, with digital cameras, you should never shoot pictures at a resolution less than the camera's highest capacity. You always want to get the most data you can out of any device, whether it's a scanner or a camera. You can always reduce the data later, but you can't add pixels back in to make a bigger picture from a smaller one. (Well, you can, but it's like getting cosmetic surgery; the real thing is always preferable, and there's a limit to how much you can do before you look, well, ridiculous.)

The most common beginner's mistake is to assume you'll save time and money (disk space, CDs, etc.) by scanning at low res first (e.g., just enough for web viewing), then making high-res scans later if there's a need to make a print or sell to a client. The assumption that appreciable time or money is being saved is erroneous. I learned the lesson the hard way; in the first few years of my photography career, I followed this logic, but I later found that I had thousands of images that were virtually useless to me. That is, if someone ordered a print, I had to go back and find the slide and rescan it (plus edit it to match my original scan), a time-consuming process that wouldn't have been necessary if I'd just scanned it at full resolution the first time. Once orders started coming in fairly regularly, I found I was wasting a lot of time redoing images. Pity, too, since it takes almost the same amount of time to do a high-res scan as a low-res one. As for the cost of the extra storage media (disks, DVDs, or CDs), it's negligible.

Once film is scanned, you have a digital image, which is pretty much where the process begins for digital photography. The only thing left to do with slides now is to store them for archives and hope you never have to pull them out again.

After initial sub-sorting and editingof my slides, the second phase is a more focused look for the best image from each subcategory. At this stage, I would rather only deal with digital images, so I review the details of each slide with an 8x loupe and affix a "green dot" sticker to the slide mounts of those pictures that are to be scanned. (This is very useful—if you ever have to go back to rescan something, you don't have to sift through the lot to see which you chose last time.) Another third of the images are eliminated during this phase.

I am now left with about one third of the total number of photos I took. (Earlier in my career, I had a lower ratio of quality pictures, presumably because I wasn't as skilled, despite my mother's claims.) Even though I've got a third left, don't assume that these are all different photos. Many are groups of similar-but-different pictures. (See photo, below.) Having "duplicates" of good photos is like an insurance policy if something happens to a slide, or you need different takes on the same subject—different orientations (horizontal and vertical), facial expressions, and so on. This goes for digital, as well.

archiving photos

Storing images in long-term archives is extremely important. For slides, I store them in side-loaded slide pages (chosen because the page will be hanging from its side in the top of a box—see the photo at right). I buy archival quality slide pages from my pro camera store, but the file boxes can be purchased at any office supply store. (Those sold by photo companies cost two to three times as much for just about the same thing.) The side-loaded pages I use hang inside these boxes using hangers that you buy along with the pages—they are not sold together. I usually have each box represent an entire country, and then segment the pages inside by sub-regions, topics, or specialty subjects. I even hang folders for brochures, receipts, or other information collected from the trip in the same box with my slides.

For digital images, I store the color-corrected scans and digitally captured images in external storage devices, such as DVDs or external hard drives (see page 67 for more information). (I may use less expensive CDs for smaller collections, or if I'm sending a disk to a client.) Because of the number of images that can fit onto a DVD, it's impractical to make an index print—there are just too many images. Instead, I print a list of the directory hierarchy and place it in the inside of the jewel case. When looking for photos, I know what disks to look at based on this info.

I always store digital images in TIFF format (not JPEG or GIF) since it doesn't lose data when saved to a file on disk, whereas JPEG and GIF both lose data in smaller sizes. What I mean by "lose" data is that the by-product of storing image information in these formats is similar to how a copy machine deteriorates an image as you make copies of copies. For your own archives, you want to save the original data, so use TIFF. Use JPEG to send copies to someone, or for use on the web. JPEG will print just as well as TIFF, so long as it hasn't been deteriorated from rounds of open/save sessions.

Some digital cameras have an option to shoot images in RAW format. Each brand of camera has their own proprietary version of a RAW file (such as Canon's CR2 files, Nikon's NEFs, or Minolta's MRWs). One reason to shoot in RAW format is so you can change white balance settings after you download the image. For example, incandescent light (i.e., indoor lighting) looks very orange if the white balance is set for standard daylight. Shooting in

RAW mode saves an image in a state where you can change the white balance later to match the lighting of the shot if necessary, thereby correcting the colors appropriately. Whether you shoot in RAW mode or not (I don't) is entirely a matter of personal preference, or workflow—processing RAW files does take more time. There is controversy on whether there is any real benefit to shooting in RAW mode. Some would argue that, assuming you shoot using the correct white balance in the first place, there is no real benefit to RAW mode. Others argue that future versions of RAW mode from some manufacturers will provide enhanced features not yet available. It's beyond the scope of this discussion to weigh in on the controversy, except to remind you that RAW mode will consume considerable time in processing images. The more you shoot, the more this eats into your workflow. However you capture images in your camera, you'll want to archive your edited image files in the TIFF format. You may also choose to save a RAW format copy as well, if you feel that it's important, but the advantage of saving in TIFF is that it's a standard that will always exist. Your camera's brand of RAW file may not, and if that's all you have saved, your ability to edit those images in the future could be compromised.

photo editing with digital photography

Whether I shoot film or digital, the final image must be digitally corrected for dust, color balance, and other anomalies. This concept is surprising to people who are under the misconception that film scanners take pictures of film to yield an identical copy. In fact, scanners never scan images correctly, but then they aren't really designed to, either. Their goal is merely to approximate the colors as closely as they can without losing valuable image information, and to minimize the amount of noise (the digital equivalent of grain) in the darker, shadowy areas of the image. Odd as it sounds, those two objectives are at odds with one another. Picking up detail without introducing noise does not result in an "identical copy" of the film. You have to make appropriate digital adjustments to correct the image back to the original "reality" of the scene as you remember it.

It turns out that images from digital cameras require exactly the same thing, although to a considerably lesser degree. That is, digital cameras can reproduce images more accurately than a scanner, and with refreshingly realistic results. However, they are still not perfect. At the very least (for professional-level digital SLRs), dust can get onto the digital sensor when you change lenses, so you'll have to edit out dust spots. Even with dust-free, airtight bodies, light and color balance are often too imperfect to yield a saleable picture right out of the camera. Alas, as you get more sophisticated with your photography and your art form, you'll eventually find that just about every image needs adjustments of some sort, whether it's color calibration, contrast or hue control, or even artistic necessity alterations (conversion to black and white, for example). There are many books on how to correct, alter, fix, or even abuse photos digitally, but we won't cover all that here. Suffice it to say that it's a vital process of the "commercialization" of your images.

monitors and color calibration

While I don't discuss digital editing techniques in this book, you should know that the most important piece of computer equipment you can own is the monitor. Unless it is color-calibrated, what you see may not be what your clients sees, or what you get in print. No matter what kind of monitor you have, it always needs calibration. The quality of the monitor affects the degree of color accuracy you can achieve. How quickly it gets out of calibration is another problem entirely. That is more of a function of age. So, if you're using an inexpensive monitor, you can still calibrate it (and you should), but depending on how seriously you want to take your photography, your second biggest investment in this business (behind your camera gear) will be a quality monitor.

If you research which monitors are "best" for photo editing, you will find nothing but expensive choices. Fortunately, you don't need to buy the most expensive monitor for superb results. Better still, you can do pretty well with mid-range monitors. Here are some quick guidelines for choosing a monitor.

CRTs are better than LCDs: The traditional CRT (cathode ray tube) screens, which look like huge TV sets, have habitually been more accurate for color than LCD (liquid crystal display) screens. However, the demand for quality LCDs is growing. At the time of this writing, Apple's Cinema Display, and LaCie LCD monitors (both of which are like high-definition TVs) are able to render color accuracy like the best CRTs available. But the price tag for these high-end LCDs hardly makes it worthwhile unless money isn't a concern. Of course, this is not likely to remain the case for long, so do research on current LCD versus CRT comparisons, along with their price ranges, before making a big purchase decision. Either way, the CRT option is never a mistake, and will almost always cost considerably less than an LCD.

Size Matters: When I was getting started, I was happy with a 17-inch monitor, then 19 inches a few years later. But, prices weren't as low then as they are today. For serious production work and reliable quality at a reasonable price, a 21-inch monitor is the best choice. Once you get to this size, most models and brands are good. (One doesn't build a monitor this size using cheap parts.) The importance of size is not just so you can see as much of an image on a page as possible, but so you have enough room to do other things as well. This is often grossly underestimated as a matter of productivity. I've had perfectly good use from PC monitors that come directly from the manu-facturer, as opposed to buying specialized ones from specialized monitor companies. That said, I have also purchased a 22-inch LaCie Electric Blue that's also been perfectly good to me.

Dot Pitch: This is not just a nit-picky "techie spec." It's important, despite its confusing definition: It refers to a monitor's ability to render a pixel properly. You want to look for monitors that have the lowest dot pitch you can find. The current "best bet" monitors have dot pitches of around .24 and .25. (LCDs usually rate around .29.)

Calibrate!: No monitor is worth anything if it's not calibrated, and the only way to reliably calibrate a monitor is by using a device that sticks onto the front of your screen and tells you how to adjust the red, green, and blue levels; some even adjust the levels for you. These devices are in the couple-hundred dollar range, and they vary in quality and feature sets, but even the worst ones are vastly superior to you doing it yourself. Unless you have such a device, you've wasted all the money you spent on your monitor—any monitor.

redundancy and device independence

As a general rule, you should always think of your PC as an expendable device that can suddenly become useless at any given time. Therefore, you need to archive images onto some other device besides your computer. External hard drives, for example, can attach to any computer. You can also use removable media, like CDs and DVDs. The key to these is that they are device-independent. That is, any kind of computer can read CDs or DVDs, whether it's a PC running Windows, or a Mac, or a Linux machine. Even non-computer devices, such as entertainment electronics, can read photos from these media. You can even plug them into photo printing kiosks. So, if your computer ever breaks, and you upgrade, or even change brands, your removable media and your external hard drives will just plug right in. But, which of these should you use? One, or the other, or all of the above?

removable storage Write-once media, like CDs and DVDs, assures that your data will not suffer from viruses or accidental file removal. Even the curious and probing fingers of a toddler who loves blinking lights cannot remove the data from a DVD-R or a CD-R disk. Both these formats are good, but DVD is preferred because it has more data capacity (4.7 GB vs. the 700 MB available on a typical CD). Please note, however, that you only want to use "write-once" disks, which are designated with an "R"—not the "RW" disks that let you erase and rewrite perpetually. As inviting as it may be to have such convenience, their archival ratings are poor. Only use RW disks for short transfers of data, like if you make a special collection to take to a client, to give a presentation, or to tote your images to the local photo kiosk. Also, while most computers come with CD and DVD drives that can

read/write, I highly suggest using an external DVD drive that can connect to any computer. Again, if your system is down, you can take your DVD drive to someone else's computer, which may not have one. (Make sure you keep the installation software disks!)

external hard drives The reason for using an external hard drive is for convenience. That is, having tons of DVDs sitting around can be cumbersome, especially if you find you have to go back and search for images often. If you have a hard drive plugged into your computer that houses several thousand images, it's quick and easy to get to them. Hard drives have the additional benefit of being a singular item you can take with you on trips, both for storage and in the event that you get an order and need access to your high-res images. Usually, you can fit your entire professional career's worth of photos onto a manageable number of hard disks, but the same cannot be said of DVDs. I personally carry a back-up hard drive with me on trips, along with my laptop, so I can fill any order anytime. The main disadvantages to external hard drives are these: First, they can break, which brings us back to the main advantages of DVDs, which are less susceptible to damage. Similarly, unlike DVDs, external drives are writable by the computer while it's in operation, which means they can be damaged by a computer virus.

Cost can be a concern when purchasing storage media; different types of storage media cost vastly different sums of money. However, it eventually breaks down to dollars-per-gigabyte of storage. The cheapest option—and, as it turns out, the most convenient for back-up and recovery—is an external hard drive. I try to buy the least expensive product from the best manufacturers, which usually means 200 to 400 gigabytes with a speed of 5400 rpm (revolutions per minute) from Maxtor or Western Digital. The slower RPMs mean that access times are slower than what you normally find on the main hard drive on your computer but, because these are backup drives, you don't need high-performance. They're going to sit in a cool, dry, dark place somewhere in your house (or at your parents, or the bank), only to be brought out occasionally for archiving or recovery.

Here's another hint: Don't buy the complete "external drives." Instead, buy an internal drive and an external housing for it. As two separate units (drive and housing), this combo kit ends up costing half the price of a whole external drive kit, but it's exactly the same thing. Just assemble it and plug it into the USB or FireWire port on your computer. After formatting the drive and copying your images to it, unplug and store it. (Oh, and don't forget to label what's on the drive. Make a screen grab print of a directory tree that shows what's on the drive, then tape it to the drive's enclosure.)

image database software

Okay, now that you have your images scanned and archived, what do you do if a client calls and asks for a vertical image of a boy with a dog at a beach? Chance are, if you've shot for many years, you won't remember each picture that might fit this description, or where to find it. Here's another scenario: Someone asks to license an image for a food magazine, but only if it hasn't been published by another magazine in the same industry. Lastly, try this one on for size: You need to find all the images that have been purchased as prints by customers in your own state so you can generate a thumbnail contact sheet to present to the franchise tax board that's auditing your records to see if you've properly paid your sales taxes.

What all these scenarios have in common is that they require records of what you've got, information about it, and knowing where to find it. Storing images is one thing; finding and recovering them is another. Tying them into an accounting system or a customer base is yet another thing altogether. Here's where it gets technical, and thus, tricky to address. There are two main problems: First, different software products are more or less appropriate for different kinds of users. Secondly, different kinds of businesses may need different kinds of data. And as if this isn't hard enough to solve, there's the reality of whether you can even use these products without having a PhD in computer science. This disparity between people's needs and their abilities often leads to a dead-end.

Your options vary greatly. Dozens of general accounting and database packages are available, any one of which work, but they're not simple and they require some fiddling to configure. For example, FileMaker Pro is great for just about any business, and allows you to build and configure whatever you need. The problem is that it's time-consuming, and requires a willingness to dedicate yourself to the computer-nerd lifestyle for a substantial period of time. That said, anyone who has previous experience with home-based businesses will find such a program perfectly adequate.

Then there are products that are specific to photo businesses, which tend to pigeon-hole you into a particular kind of model that may not be yours. (It can be really frustrating to discover that these programs and their great ease-of-use features don't apply to your business.) Extensis Portfolio, InView/StockView, FotoBiz, iPhoto, and others all have

great strengths as well as serious weaknesses, and none of them will do everything that you need. In the end, you may have to do what the rest of us have reluctantly done: Pick a best-of-class product to do each of the different tasks you require. In that spirit, here is some advice on how to approach your product research:

Product Reviews: Research product reviews and see what users have to say about them. Read discussion groups, find photographers that do the type of business you do, and see what they use and why.

"Test-Drive" Products: You should never buy any of these products without first downloading trial versions from the Internet and seeing how comfortable you are with using them.

You should also build a checklist of needs. My list includes:

Keywording and Image Descriptions: I list this first because it's usually the main function of an image database. All photo database products do this, but some make the process easier than others. For me, I have thousands upon thousands of images, with thousands more added each year. I need a system that can allow me to quickly and efficiently add new keyword and description data to images en masse, as well as individually. This is much harder than people think, and every program approaches this problem in radically different ways.

Relational Database Capabilities: Do you want to have your customer database, image database, and sales database all integrated into a single package? Some programs do this, others don't. There are pros and cons, but the biggest problem is that it's a complex programming task, which introduces three concerns: product reliability, data integrity, and cost. When doing research, look very carefully at these factors, and consider the experiences of users whose businesses are most similar to yours.

Web Support: Photo database packages vary considerably in their support for web-based applications. That is, some will create web pages of your images (which you simply upload to your web server), and others will also create a template for searching your image data (which you also upload to your server). This is a quickly evolving feature of image database products, so look into what is currently good if and when you determine that you need this capability. (Also, be sure you know what your web server platform is so you don't buy an incompatible product.)

Accounting: Some all-inclusive packages understand the photo business, so they have predefined forms for you—invoices, bills, statements, and in some cases, templates for contracts. These programs will also determine your profit/loss at any given time, determine your sales tax obligations, and graph business trends. To a large degree, these are convenient and flexible. However, I don't consider this a determining factor in whether to use a program like this as a database. The main advantage to having an integrated package is that you can cross-reference photos with financial transactions, but you can only know whether this suits your needs by doing research and "test-driving" products. Such products may be more important for a stock photography business than a wedding business, for example.

Customer Data and Contact Info: If you run the kind of business that has you constantly sending out marketing materials, email newsletters, or portfolios to clients, and you need to track this information, you may value having a database package that has strong integration with sales and marketing contacts. A good package will be one that can cross-reference image and sales data with marketing activities so you can see how your marketing dollars are working for you. Needless to say, you need to have a customer database somewhere, but whether you need it in your photo database is a different matter. Find out which features a particular program supports, then compare those features to your needs.

Data Portability and Image Integrity: It is always important to consider the integrity of the program you use to store your image data. Too often, this is an issue that doesn't occur to people until well after they've committed to a product. Specifically, image keyword data is most often stored in a database file that is separate from the photos. This makes sense, but if you decide to move images around on your disk drive, change directory hierarchies, or rename images and folders, your database may not function properly anymore. Some programs require images to remain where they were when you originally created the database. For example, if you find an image you want to use and now need the high-res version, the program may only report where the image was when you first created the database, not where it's new location is, or when you moved it.

On the other end of the spectrum, products like iPhoto for Macintosh actually make the photo itself part of the database. This retains integrity, allowing you to move the data to a new computer. However, you've also just lost control of where and how you store your images independently of the database. You either move them both together, or not at all. The tradeoff here is that data integrity within the database often competes with the objective of flexibility outside the database, so you have to pick your evil.

This underscores the importance of being able to export data into a database-independent format. An example of this would be a "flat file" format that can be read by any database as well as a standard text editor. This is a highly inefficient way to manage a database, but the goal here is to merely export the data to preserve it for back-up or archival purposes, not to use it. This is especially true if you ever plan to migrate to a new or different database later on.

summary

There are many people who are satisfied with their products, but there is also a general consensus that no one product even approaches perfection. Some people just don't bother using any of them, choosing instead to use the old-tech method of paper and pencil (or the old noggin). Others pick a product, perhaps mistakenly, and stick with it because they have too much invested in it to back away from it, which is a mistake I highly advise you to avoid.

When I was getting started, most photographers were excited about Extensis Portfolio, which only handles image data (not customer info or sales data). When I did research online, I found that many large stock agencies, newspapers, and other media companies were highly dissatisfied with the product because they said that it was slow, crashed a lot, and was totally incapable of dealing with large numbers of images. But individual photographers who were more like me said they never had such problems, and that the easy user-interface was a dream to work with. So, I bought it.

Sure enough, it's features worked as well as advertised, and the user interface made it easy to assign keywords to my photos, which was my only need at the time. However, as my business grew, so did my image base, and I ended up running into exactly the problem that I had earlier dismissed: The program became greatly unstable.

I considered migrating to other products; PhotoBiz looked like a good contender with its business management tools, but the keywording and other features that were so strong with Extensis Portfolio didn't justify moving over completely. Similarly, InView/StockView had strong points that prompted further research, but at the end of the day, I realized that I was in a no-win situation. It was a zero-sum game, and by changing products, I would merely be trading one set of problems for another.

Eventually, I chose a strategy of using various best-of-class products to handle the different aspects of my business, rather than depending on one product for everything. Oddly enough, I still use Extensis Portfolio today, but to do one thing and one thing only—keywording/categorizing new images as they come in. Once this is done, I export the data and use it in other programs that are far more reliable. In short, it's an excellent keyword entry program.

My multi-product approach has its pros and cons, and what I gain in flexibility and reliability comes at the cost of having to manually consolidate or cross-reference information on an as-needed basis. Yet, the nature of my business is such that this infrequent burden is not prohibitive, and I can often do it without loss of productivity in other areas. This is by no means a recommendation that you do the same, but I should mention one enjoyable advantage that tips the scales for me: Using best-of-class products instead of one all-inclusive product frees me from being beholden to a single vendor.

My parting advice on the subject is this strong reminder: Very few emerging photographers (or businesses) really need any software when they get started. Believing you need "something" without the empirical business experiences to know exactly what that is, will slow your growth and productivity in areas that really need it. I suggest holding off on any purchase until your business grows to a point where you find you're doing certain tasks repeatedly. When you can envision having something automated to take care of tasks you're doing manually on a fairly regular basis, that's when you're ready.

5

PHOTO
PRINTING

photo printing

Printing your photographs can be a fun and rewarding process. With ink jet photo printers today, one can produce prints at home that would've been considered impossible just a few years ago. Yet, when selling prints is your business, there are other matters that you'll need to consider, such as time, cost, and print quality. We'll look at each of these as we address the business factors involved in making your own prints.

This chapter does not discuss printing methods, techniques, or other technical information, except where those factors impact your bottom line. However, I would never suggest one compromises any part of one's artwork just to feed the bottom line. There are ways to optimize existing production processes without changing the creative component, and that's what this chapter is about.

basic printing methods

There are three main ways to make a photographic print: the traditional darkroom, the home-based ink jet printer, and printing digital images on traditional photographic paper. For those that feel that the older method of printing with negatives using chemical baths is the only respectable art form, I understand. I respect that. I also admire it. If that is the craft upon which you intend to base your business, don't let me or anyone else talk you out of it. Mastering this art form is a time-consuming process that often takes years before you're making something truly unique. If this is your chosen craft, the business considerations are really only about whether you're getting the best prices for your materials. The success of your business is more about how you handle sales (see page 96 for more information).

Bear in my mind, though, that if you're making standard prints directly from a negative without the "art" component (or worse, sending slides or negatives to a lab to make prints), this is financially the worst thing you can do, and technically the worst way to make prints. It's costly, time-consuming, and prone to errors at many levels, each of which may occur every time you make a new print. The best thing to do is to scan your film into a digital format, then reproduce high quality prints that way.

digital printing

Printing from digital data sources is part of a process called digital imaging. This involves factors that include making quality prints reliably, consistently, and repeatedly. When you add the business component, you also incorporate efficiency. The two main mediums for digital printing are ink jet and "photo paper." Other less common methods include canvas printing, Giclee, and Iris prints, all of which use alternative papers and inks chosen more for creative license. As with darkroom printing, these less common printing methods are more artistic than they are practical, so we aren't really talking about these in relation to the efficiencies of a more traditional photo business.

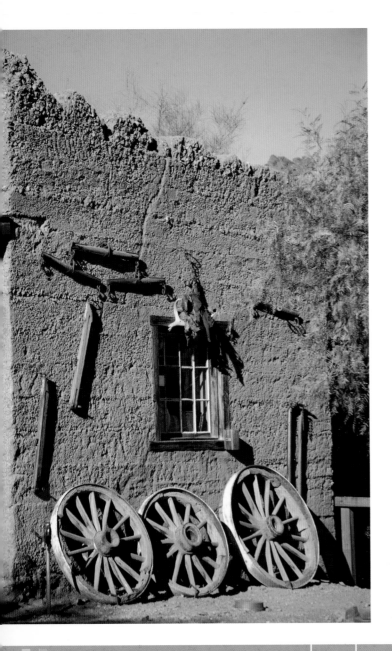

ink jet prints

If you're considering the business of selling prints, you're no doubt aware of ink jet printers. They are just about everywhere, and many people make very nice-looking prints, some of which even sell well. Where home-based ink jet printers really shine is with the higher-end products and alternative paper types, such as watercolor papers or other special paper materials. In fact, if you're doing arts-and-crafts style photography, using specialized ink jet printers is a less expensive option than using higher-end systems for Giclee or Iris printing.

If you do decide to invest in a home ink jet printing system, it's important to be aware of the difference between dye-based and pigment-based inks. For one thing, if you're even considering using pigment-based inks, you'll have to buy a printer that specifically supports their usage. Prints made with these inks have a longer lifespan (before they begin fading) than dye-based ink prints do. So, at face value, the longevity alone may make pigment inks appear to be the preferred choice. However, their color reproduction is generally perceived to be inferior to dye-based inks. The resulting prints have a unique textured watercolor look and feel, which is fine, but not the typical photographic result that many expect when printing their images. The higher price of pigment inks also sets them apart as more of a specialized craft choice. For non-art, consumer-based products like note cards, postcards, and greeting cards, it's probably most cost-effective to go to a specialty card maker for production purposes (see page 130 for more information).

For those who are just making traditional prints that go from the digital media directly onto typical ink jet photo paper, the cost and quality of these prints vs. traditional photographic prints present important considerations. Inks used in many home-based printers are not as archival as manufacturers claim, and independent studies show that only the most costly inks and papers hold their color tone and richness over a period of a few years—and this is only if they are kept in a cool, dark place. Even then, their aesthetic often does not rival photographic paper, which not only looks better, but has also already demonstrated its archival quality over the course of time. While the dynamic range of ink jet inks is impressive, a properly color-managed image may yield ever more impressive results when printed on photo paper. And if that isn't enough of an incentive, business considerations may tilt the benefits even more towards photo paper. On the cost side, ink jet prints can escalate quickly when you account for paper and ink (ink being the more expensive of the two).

photographic prints

Making traditional photo-paper prints from your digital images is cheaper than making ink jet prints, and may yield a superior product. Many photo labs offer 4 x 6-inch prints for as low as $.24 per print, and be sure to keep your eyes out for photo store and online promotions that may offer additional discounts. With any lab you choose, besides price, you should pay attention to important features like turn-around time, customer service, and photo paper quality before placing large orders. The good news is that you can test a lab quickly and inexpensively by simply making a single print.

While quality can vary widely, the main limitation at many photo labs is maximum print size—usually 8 x 10 inches, though some can make up to 12 x 18-inch prints. Professional photo labs use higher-end printers. These systems can produce prints up to 60 inches wide and, because the paper is on rolls, any length. What's more, the dynamic range of these professional printers may yield a broader gamut of colors on the paper. Basically, all these machines read digital image data and project a combination of red, green, and blue lasers that represent each pixel's color onto traditional photographic paper. The professional machines just do a better job at it, and provide you with more size options.

the resolution fallacy

When it comes to any kind of printing, dpi (dots per inch) is one of the most misunderstood aspects of this technology. While home-based ink jet printers claim to print at resolutions like 700 x 1400 dpi, this statement is misleading. They can produce ink droplets that small, but each droplet does not represent a unique pixel from the digital image. It just means that the printer can fine-tune the ink mixture more efficiently on the paper, yielding more accurate color. Like a cooking recipe, any given color can be made from a certain amount of cyan, yellow, magenta, and black. The finer the mixture, the better the color accuracy, but this is printer resolution and has nothing to do with image resolution. Most ink jet printers only require an image quality of around 200 to 300 dpi. In other words, if you printed a 700 dpi image and a 200 dpi image, you wouldn't be able to tell the difference. (Note that your image-editing software may measure the resolution in ppi—pixels per inch—though dpi is becoming the standard terminology used in the industry. See page 84 for more information.)

This is also true of the higher-end digital photo paper printers. Every printing device is different in what its actual dpi rating is, but the true differentiator is where the machine renders not just accurate colors, but smooth enlargements. On some high-end printers, I've printed very large prints at as low as 92 dpi and found the results to be exceptional. Of course, you don't really want to print at a lower dpi unless you have to. But the point is, you can get better results from lower-resolution images on higher-end printers because they have more advanced imaging technologies. (They should, since these systems usually cost around $250,000 and take up entire rooms that require strict temperature controls and chemical balancing.) As a business matter, selling a 40 x 60-inch print to an office complex usually translates to $1100 or more, so knowing how to print at these sizes is worthwhile.

dye-sublimation prints

Be careful about the "instant printing" kiosks that allow you to wait 3 - 5 minutes for your print to come out. These do not use photo-based papers; they are dye-sublimation (a.k.a., "dye-sub") printers. While they used to be considered high-end before modern ink jet technology evolved, these are not really all that great anymore. Dye-sub printers (which can also be purchased for the home) do, however, have one great feature in that there are no "dots"—the ink is pressed onto the paper by a kind of rolling pin that presses each of four separately dyed sheets of ink. At one time, this was considered high-end technology because of the smoothness of colors without dot patterns. Yet, the inks are more susceptible to fading than modern ink jet inks, and image resolution is not rendered as finely as contemporary ink jet printers are capable of.

your print vendor

Regardless of how or what you're printing, choosing a printing vendor is important. And don't assume that just because one vendor costs more than another that its quality must be better. There is no correlation between quality and price; if the staff isn't trained well (for color calibration and dust control), you can get bad prints regardless of how much you pay. However, the reality is that "bad prints" are more likely going to be your fault, not the photo lab's. The digital printers used by printing vendors are automatically and frequently calibrated, so if an image doesn't come out like you expected, chances are that your computer monitor is out of calibration, not the printer.

For small prints (smaller than 8 x 10 inches), I go to my local photo store, which is about two blocks away. But for bigger prints that I sell on my website, I use professional photo labs that let me upload my photos to their site and print by submitting an order form. I don't have to leave my house, send a disk, or even talk to a customer-service person to place an order. Assuming the vendor has an automated site for handling my printing needs, the other main criteria for a good service provider are turn-around time and customer service (if something goes wrong). Usually you won't learn much about the latter until there is a problem, so don't just take their service guarantees at face value until you've really put them to the test.

summary

The most important aspect to managing a photo business that sells prints is whether you're making a product that's worth the money you're selling it for. Once you've got that point down, your success in business is then governed by the choices you make in materials, processes, and vendors. Your job is to figure out how to make a consistent quality product while managing time and cost efficiently.

The per-print cost of using the high-end, large format printers rivals that of ink jet prints and even the lower-end printers (although vendors' prices vary considerably) up to size 8 x 10-inch prints. At larger sizes, ink jets may be cheaper to use on a per-print basis (if you choose low-cost inks), but whatever savings you may realize are usually offset by the cost of the printers themselves, not to mention permanence issues.

As per my usual advice, use a search engine to find a good lab, or query photo newsgroups to hear what others have to say about any given lab and the issues in dealing with them. These days, you do not necessarily need to use a local lab. Most photo labs have websites where you can upload your photos and they send you the prints in the mail.

6

UNDERSTANDING RESOLUTION

understanding resolution

When in the business of selling or licensing photos for use in print (magazines, posters, catalogs, billboards, packaging, etc.), the very first technical matter you'll face is deciding what resolution is necessary to reproduce a quality image. Often, you'll hear the request: "Send me a high-resolution image to use in the brochure." As you will soon learn, this tells you nothing. It's like saying to a hair stylist, "Give me a haircut." You can imagine the response: "Okay... how much do you want cut?" Similarly, perhaps you've heard this expression: "I'd like to license that image at·300 dpi." Again, this statement does not provide enough information. That's like going to the grocery store and saying, "I'd like to buy apples at $.99 a pound," as you hold out an open bag. The guy will just look at you blankly, waiting for you to specify how many pounds of apples you want.

reviewing terminology

When it comes to both resolution and dpi (dots per inch), it's the same issue. The expressions are meaningless on their own, but have become so commonplace that it only causes frustration when the people who actually use the images (or pay for them) realize that they should have been more specific. Understanding these terms is key to supplying your clients with the image files they need.

resolution It is common to confuse "dpi" with the term, "resolution." The two are often used interchangeably in discussion, but there is a huge difference in meaning. Resolution refers to the total number of pixels in an image—it's an absolute value. For example, one might

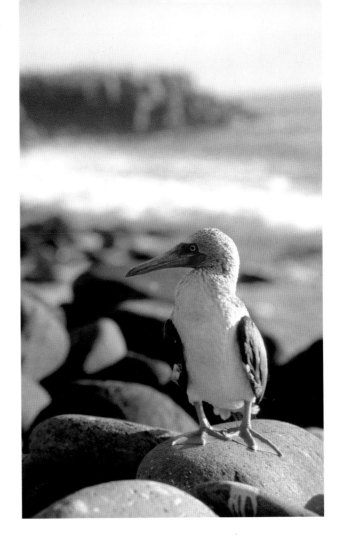

say, "This photo has a resolution of 5 million pixels," which means that there are a total of 5 million pixels in the entire image. You don't know whether it's square or rectangular, because you don't know how many pixels represent the vertical or horizontal dimensions. You just know the total number of pixels that make up the image.

Resolution can also be expressed in dimensions. Let's say we know that the 5-million pixel image measures 2500 pixels wide and 2000 pixels high. It has a resolution of 2500 x 2000 pixels (2500 x 2000= 5,000,000). This is a fixed resolution, but not a fixed print size. You know how many pixels you've got, but the image measurements will depend on how the image will be output or otherwise used.

dots per inch Getting down to basics, dpi stands for "dots per inch." (Apologies to those countries that use the infinitely more rational metric system.) You may run into the term ppi, which means "pixels per inch." The two terms have become synonymous in everyday use.

Scanners, for example, scan film and create digital images that are measured in pixels. The same goes for computer monitors: they present images in "pixels." (Inkjet printers, by contrast, create dots of ink.) Thus, scanners are considered to produce an image measured in pixels per inch, then you work on this image in the computer using pixels per inch, but when you send the image to a printer, in produces a print with a certain number of dots per inch. This explanation accounts for the different terminology. However, the use of "ppi," while still present (mostly in technical documentation), has been supplanted with the more common, "dpi." To finally clarify the point: every "picture element" (pixel) of a digital image corresponds to one of those "dots" in a final print. Now, you can expand, contract, or even "smudge" those dots creatively to produce larger or smaller pictures, but we'll get into that later. For now, we'll start with the basics: a direct translation.

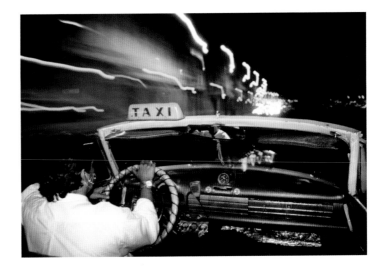

input vs. output

Every device that deals with digital images must share a common ground to understand the media that it's working with, whether that device is reading from the media, or writing to the media. Translating between input and output devices so that the image retains its integrity is where dpi comes in. For example, you may scan a photo from film, and then send the resulting image to a printer. The film may be only an inch wide, but you want to print it on an 8 x 10-inch sheet of paper. Going from this smaller size to a larger one requires a translation of sorts. To do this, you need to know what the capability of the scanner is so you can translate it to values that make sense for the printer.

As it applies to real-world scenarios, you may hear instructions for image scanning and delivery that incorporate both ppi and dpi, so as to communicate that there is a translation to be done. For example, "Scan the film at 3000 ppi and deliver the image file to me at 300 dpi." Here, you can easily see there are two different measurements taking place.

The more important point to all this is the actual translation from input (scanning) to output (printing). Doing the math for a hypothetical project, 3000 is ten times more than 300, so scanning film at 3000 ppi will yield an image that will produce a print that's ten times the size of the original film if the printer prints the image at 300 dpi. Thus, if film is one inch wide and scanned at 3000 ppi, you'll get a ten-inch print from a printer that outputs at 300 dpi.

Matching up the scanner to the output device is not really as difficult as many people think it is. In fact, it usually doesn't matter what the film is scanned at, provided it's large enough for the final output resolution. For that reason, it's always best to scan film at the highest resolution the scanner is capable of so you can "resize" your images to whatever final resolution a potential client may need.

scanning film

So far, we've only been dealing with output measurements, using a hypothetical image that has a fixed resolution size. However, we must now look at how we input image data from a source like scanned film or a digital camera to create the final image. In this case, we're examining ppi in relation to a scanner. Consider what you'd get if you scanned a frame of 35mm film at 300 ppi, and then printed that image on your home printer. Doing the math, a 35mm frame of film is 0.9 x 1.6 inches so a 300 ppi scan yields a 270 x 340 pixel image. If you print that final image on a home printer and don't change the dpi value, you would only get a picture that's .9 x 1.6 inches—the same size as the original filmstrip. This experiment always surprises people who expect an enlargement. Given what we've learned, you know why this happened; the input ppi was identical to the output dpi, which means that there was no magnification done at all. It's a pixel-for-pixel reproduction. Let's look further at this to see exactly what's going on.

putting
resolution to use

Let's say you are looking at a 4 x 6-inch print of a 2000 x 2500 pixel image; the pixels are really, really tiny, so there might be many hundreds of dots per inch. Now imagine that same image projected onto a wall using a slide projector. The farther back the projector moves from the wall, the bigger the picture appears. What's going on is intuitive; the light projects the "dots" on the wall, spreading them farther apart as the projector backs up. How many of those "dots" represent an inch changes as the projector moves, even though the original image isn't changing at all.

Let's apply this concept to a real life scenario. Looking at the photos on this page, you can see how the translation occurs. The original moon rise photo has tiny "dots," (so tiny you can't see them), and the truck is covered with a huge sheet of paper that has big "dots" with more space between them. Where dpi comes in is when you're talking about how many of those dots represent an inch. The goal here is similar to that of setting up a projection screen on one end of the room and a slide projector on the other. You want to fit the entire image onto the screen, so you push the projector back and forth until it fits. In this example, it's easy because it doesn't cost anything to project the image in different sizes—you just move the projector. But, for the truck, it would be wasteful and expensive to make a bunch of test prints with different dpi values until we have one where the image happens to match the paper size. Fortunately, the solution is simple; we just calculate the total square inches of the paper and multiply times the number of dots the printer "projects" onto that paper.

While the method above is technically correct, there is one catch to it: We don't know if the printer itself can actually produce a print at the final dpi value we came up with. To discuss this, let's return to our example image that has a resolution of 2500 x 2000 pixels. If you send that data to a printer that prints images at 300 dpi, then the 2500 pixels in the horizontal dimension will produce an image that's about 8 inches wide. This is hardly big enough for a truck. If, on the other hand, the printer only requires 50 dpi, the same 2500 pixels will produce 50 inches of that image. That is probably sufficient for our needs.

To extend the supposition, if you're using the image on a billboard, the printing device for this purpose probably prints at 5-10 dpi, which can yield pictures that span widths of whole buildings! You can really see how few dots per inch are on a billboard if you get close enough (as I did, shown in the photo here).

So, back to the image printed on the truck, the question is: What are the dpi specifications of the printing device? Does it print at 20 dpi or 300 dpi? The point is, we need to find out, and then assure that we provide a digital image that has enough pixels so that the image can be printed properly. Too few pixels and the image will dissipate, like the slide projector that gets too far from the wall.

The whole reason for specifying a dpi value is to adjust your image to match (or get within acceptable ranges of) the output capabilities of the printing device. People who know this stuff don't just ask for a high-res image or a 300 dpi image; they either ask for an image at a specific resolution, or indicate the final output size along with the dpi.

This raises important questions:

What resolution is really necessary for any given printing need?

What do I do when I'm not sure?

What if I can't achieve or deliver the desired resolution?

The person who ordered the image for the truck didn't know the dpi capability of the printer that would be used, so I had to call the paper manufacturer to determine what dpi his device printed at. Turned out, it was about 24 dpi. So, the only other factor I needed to know was the size of the print surface, which was about 14 x 6 feet, or 168 x 72 inches. To calculate the image resolution I needed to provide for them, I just multiplied each dimension by 24 dots per inch; this means that the truck required a 4032 x 1728 pixel image. This is easily handled by a 35mm frame of film, although a tad more than what an eight megapixel camera can handle.

the business of resolution

In the days when scanning photos to create digital images was new, if someone asked for a film scan, they just got the highest resolution possible because the cost of scanning any film was so high, that getting anything less would be a waste of money. So, people would always ask for a "high res" scan. This would, in turn, be delivered to a client, who would then reduce it to whatever size they needed.

Nowadays, digital images have greater value as their resolutions increase, which is changing the way images are priced. The growing trend is for licensed images to be priced on overall pixel count (or, "the size of the picture"), regardless of the size at which it may be printed, or even which media is used. In other words, if someone requests an image at 300 dpi to produce a 20 x 30-inch poster, they could be paying twice as much for an image that would reproduce just as well at 150 dpi. In essence, they could have licensed an image at half the size, for half the price, and gotten exactly the same quality result. So, delivering "high res" images could end up either costing clients a lot more than they need to spend, or conversely, cause suppliers to give away more than they need to.

tricky and sticky It can get tricky and sticky to determine the "real" dpi values for any given device. There is no universal dpi that's consistent across all printing platforms, just as there is no single, universal hair length for, "Give me a haircut." Although dpi values vary dramatically, most people who request images have no idea what output their printing device is actually capable of, but 300 dpi is the de-facto standard for historical reasons.

Since most printing systems can print consistently adequate results at 300 dpi, there's not a huge incentive to fight the norm. So, when a graphic designer insists that you provide an image at 300 dpi, even though they don't really need it, it's sometimes best to just let them have it. (You still need to know the final output dimensions in inches though!) The exceptions to this come in when costs are involved (i.e., the client wants to spend less money), or it's physically impossible to meet the specs. We'll illustrate these scenarios in the next section.

Q & A Exercises

Let's test your knowledge of the information we've covered:

Q: You've sold a photo to a magazine publisher who wants to use it in an article. They ask you for a digital image that's 300 dpi. What do you give them?

A: There is no correct answer to this until you know what their final desired output size is. If they say they're going to print a quarter-page, you still don't know. You need a specific size measurement, preferably in inches, so that you can apply those 300 dots per inch to a specific space. (If you get mm or cm, you'll have to convert to inches first.) For example, if they request the image to be 9 inches high, multiply that by the requested 300 dpi and you know that your vertical resolution is 2700 pixels. (When you enter this pixel measurement into your software's sizing dialog box, the corresponding horizontal resolution should appear automatically.)

Q: Do they really need an image at 300 dpi? How do you know?

A: As discussed earlier, the claim that they need an image at 300 dpi is often based on historical assumptions, not actual device specifications. Chances are, this isn't the real number they need. As image printing has evolved, the ability to print quality images from lower-resolution files has improved considerably. However, knowing this technical fact may not help your business relationship. More often than not, you should just let them have it at 300 dpi. On the other hand, if your client is wary of the licensing fee, offer the image at a reduced resolution for a reduced fee and educate them to the fact that a 200 dpi file is likely to print as well as a 300 dpi file. At 2/3 of the cost, they may find your argument particularly persuasive.

Q: A toy company wants to use an image for the cover of a game box that's 30 x 30 inches. They say that they want an image at 300 dpi. What do you give them?

A: Doing quick calculations, that's a total resolution of 9000 x 9000 pixels. You're in a pickle because you can't deliver a digital image that big unless you originally shot it with a large-format camera. Neither 35mm film nor digital cameras (currently) can produce a digital image that big. You might think you can use a very high-resolution drum scanner to read your 35mm film and give a high-res file, but that will only result in a lot of noise because the film's grain isn't small enough to go unnoticed. The scanner will read between the grains, yielding a digital image that's nearly useless. (Most 35mm film can't be scanned any higher than 4000 dpi without yielding more noise than actual image data.)

The "correct" thing to do in this case is to explain that the highest resolution file you have is likely to be sufficient, and that they should run a test print to check. If you can't get them to do that, or if the test print still yields a coarse image due to pixilation, an alternative is to use software (like Photoshop or Genuine Fractals, for example) to "interpolate up" the image. That is, you can add pixels based on imaging algorithms that are designed to maintain the integrity of the picture while increasing its overall resolution. There are limits to how far this technique will work, but the good news is that if you're dealing with a client where those exceptions would apply, they probably already know how to correct the problem on their own.

On the other hand, they might not. I had one client that was so worried that the 300 dpi file I had given her would be insufficient for the print job that she insisted would only work with a 600 dpi file. I tried to tell her that the image would work just fine given the final output size she needed, but I was unable to convince her. Finally, I broke down and sent her a new file, but it was merely the same image with the the dpi value changed from 300 to 600. The print came out as expected, and she was perfectly happy with the results.

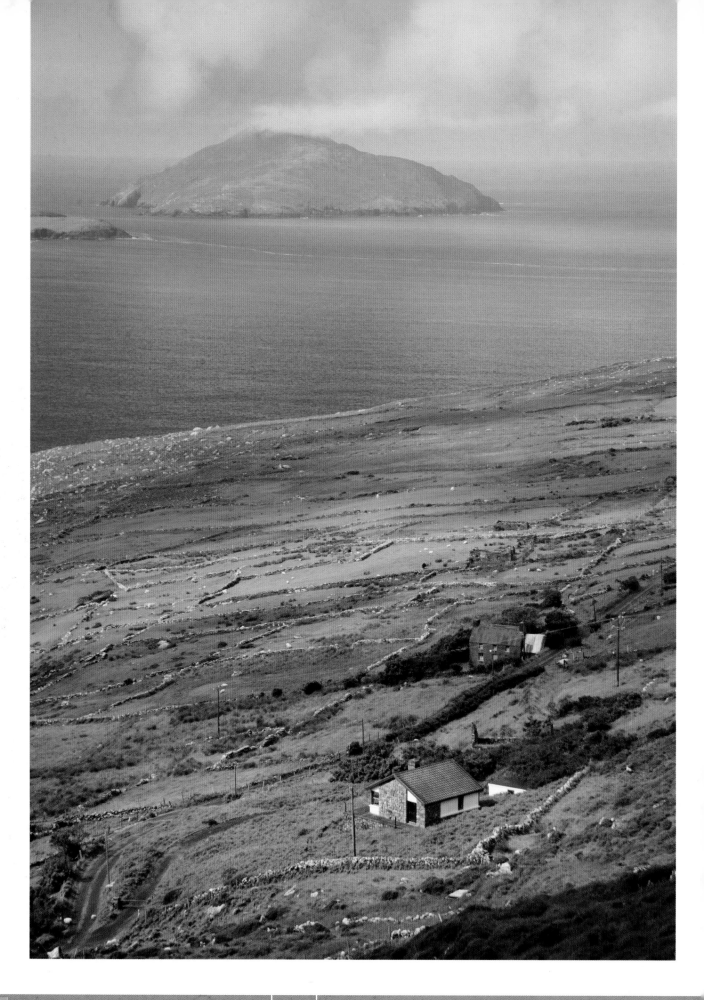

summary

Obviously, you need to deliver an image that's right for its intended use. Supplying too much or too little data only makes things harder for everyone. What's more, if the price of the license is based on image resolution (which is the convention today), it's in everyone's best interests to determine what the real dpi needs are so the final resolution can be determined and the appropriate image delivered. In practical terms, you're rarely going to convince a photo editor that they don't really need a 300 dpi file, but you must at least establish the final output size before you can deliver anything.

Digital cameras have similar considerations because they can capture images in multiple resolutions. However, since every camera has its limits, you may have limits on which shots you can license. Digital cameras don't measure images in terms of "dots per inch," they just capture a fixed number of pixels for any given picture. While you can choose to set your resolution to various sizes, as with scanning a photo, you should capture the highest resolution possible to optimize your image quality and your business opportunities. An eight-megapixel camera has a total resolution of about 3520 x 2344 pixels—not as much resolution as 35mm when scanned at its maximum setting, but sufficient for many commercial needs. Images shot at this resolution can also produce fine art prints up to 14 x 20 inches, with sufficiently artful image-editing skills. As digital cameras have evolved, so have their resolution capabilities, making many of these issues less of a concern.

SELLING PHOTOGRAPHIC PRINTS

selling photographic prints

Think of big-name photographers like Ansel Adams, Henri Cartier-Bresson, Annie Leibovitz, Edward Weston, Sebastiao Salgado, etc. You see their prints copiously in books in major retailers' photography sections, but you also see their original prints in art galleries and museums, always drawing crowds of admirers, garnering thousands of dollars per print. When photographers think of selling prints, they usually think of their works hanging in museums or galleries, with book contracts and major agency representation. Not surprisingly, it rarely happens to them. But that doesn't mean it's futile to try selling your art. The market for selling prints extends to everyday people, too.

By understanding the art-buying market, which is extremely broad, you can establish how your own work fits into it. This helps you identify your target customers and determine where they go to purchase. Once you're in the right place with the right buyers, understanding their buying decisions is critical. This helps direct you towards the best ways to "package" your product, including setting price points.

who buys photography as art?

There are essentially three kinds of art buyers, and although they fall into discrete categories, they do overlap, so prepare for caveats to the rules that follow. For now, let's just define each of the classes of buyers: collectors, aficionados, and consumers.

art collectors This group sits at the top of the food chain. The collector acquires well-known works, whether on a large or small scale, and does so mostly for the investment potential (i.e., financial return). Indeed, the art collector has an appreciation for the medium, and is extremely well-informed about the craft, the history, and who's who in the photo world. While the collector may also buy certain pieces for their intrinsic beauty and other qualities, usually only the works of well-known artists are considered. Unfortunately, this market segment tends to be somewhat incestuous, so unless you're already a part of it, the collector isn't likely to be your target buyer.

art aficionados The second kind of photography buyer is the aficionado, one who buys art for the sake of the art itself, not necessarily for its resale value (although that never hurts!). Because of the breadth of this category—the "collector" class at the high end, and the "consumer" class at the low end—this group needs to be subcategorized.

The High-End Aficionado: This is the art buyer who knows the art world well, but doesn't collect or invest because of limited funds. This presents an opportunity for the accomplished (but still relatively unknown) artist who's exhibited before and is generally well-received. Getting an opportunity to exhibit work at public TV or radio events (or other high-brow, educational, or elite functions) is a great way to get exposure in this class. Donating art for fund-raising drives that attract affluent benefactors is another avenue, though it doesn't yield income. (Remember, it's the exposure that matters; the income will usually come as you get better known.)

The Pretend Aficionado: Many people are attracted to the art market that don't know much about it—the pretend aficionados don't know what they don't know. For example, he or she may know Henri Cartier-Bresson's name and some of his works, yet may not be able to identify a piece they're unfamiliar with as being one of his. Even so, he or she speaks confidently about the art form, unaware of making factual errors. Normally, one would overlook the pretend aficionados, except that they do buy from good artists, even though they're not exactly experienced at it.

The Aficionado "Wannabe": The "wannabes" are ambitious about art and are still learning. Inexperience makes them overly cautious in what they choose to buy, often waffling so much that the sales cycle tends to be lengthy and, at times, frustrating. But, they do love photography, even though their tastes are often inconsistent and undeveloped. On the upside, wannabes are not afraid of spending money for artwork, although they usually buy less-expensive works that higher-end buyers wouldn't touch (which makes this group of buyers more accessible to the emerging artist). Wannabes can often be found seeking bargains at fairs, street markets, cafés, and other venues that exhibit art, right alongside the consumer art buyers.

the consumer For the purpose of this defenition, consumers have little to no appreciable knowledge of art. (If they did, they'd be classified in one of the aficionado categories.) One stereotype would be the person nodding in disbelief upon seeing a black-and-white photo of a chair in an empty white room selling for $500. Most consumers buy photography in the form of postcards, calendars, posters, trinkets, and framed prints sold at tourist shops for $50 or less. Poster stores in shopping malls may also sell some well-known photographs as framed pieces, but these are just high-end posters. Consumers will also buy photo books, but this is not classified as an art sale. It's a consumer product, and the business isn't photography, it's publishing.

Keep in mind that many photographers consider the consumer market to be a career-killer for the "true artist." Since it is frowned upon by art directors, gallery owners, and museum curators, those who are serious about developing their credibility as an artist often try to avoid anything consumer-related for fear that it will come back to haunt them. If you want to "make money" though, the consumer is definitely the most accessible audience; they're easy to find, there are millions of them, and what they don't pay in higher prices, they make up for in volume. This, in turn, requires quantity, which means you

need to set up a significant infrastructure to offset the costs and administrative overhead. Those who attempt this path often find that the business is not so much about photography as it is about distribution. The best way to sell art to the consumer is by licensing photos to companies that are already in (or sell to) the retail sales channel. For that, you need to get into the business of stock photography, which is not about selling prints. (Stock photography is the business of selling your existing images to companies—such as publishers—who then use or sell your images for other purposes, like advertising, publishing, etc. The fact that you hold your images "in stock" serves as the basis for the name of this type of business.)

The second best way to sell to the consumer is to create a dedicated sales infrastructure that involves having an inventory of good prints and a willingness to sit for weekends in art fairs, to promote yourself to local art venues, and to submit works to competitions for name-recognition value. (See page 96 for more about sales.)

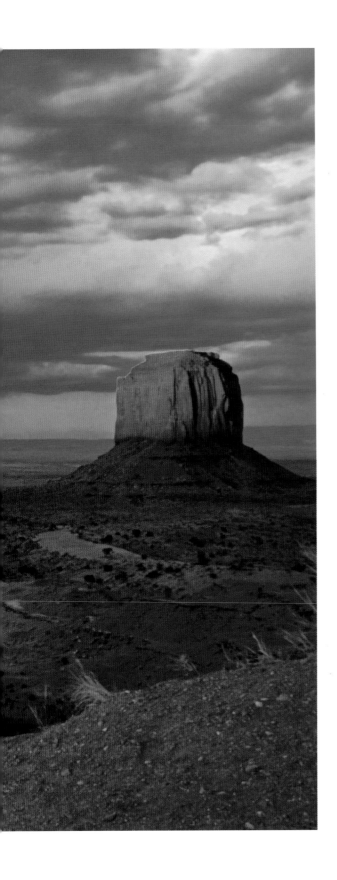

spontaneous buyers There is another set of buyers out there that can be a member of any of the previous categories: the spontaneous or impulsive buyer. Some buy just because they're on vacation and the impulse hits them, but there are also those who buy because they need something. In general, this is an unpredictable and often unreliable group, but their randomness can account for an appreciable percentage of sales if you position your sales locale well. For example, if you live in a tourist community, you'd want your work to be accessible in the highly trafficked areas of town. In non-touristy locations, or just for general sales purposes, you may want to exhibit works near design centers or other places that sell home or office furnishings. This might give you access to someone who just bought a new house or moved into a new office. Some of these people hire professional art buyers or decorators to acquire art for them to solve this need, so getting close with such people is a good idea. Commercial space is also often filled with art that is acquired by such professionals. Since quality and cost are both critical here, and since art displayed in a public space entails a risk assessment (artwork could be damaged or stolen), buyers for these types of venues sometimes acquire work from undiscovered artists, like you and me. It's cheaper than buying a big name piece and, therefore, the financial risk is lessened. (Of course, this rule of thumb varies considerably from location to location; the local City Hall may choose a dreadful piece solely because the artist is a famous icon from the city.)

There are no strategies to specifically target the spontaneous buyer because they follow the same buying patterns as other buyers do. However, the one difference is that they go through the buying process at an accelerated rate. That is, when they decide to buy something, whether out of necessity or spontaneity, they make purchasing decisions quickly. The key lesson to learn in dealing with this kind of buyer is to stop selling. We artists get excited when someone shows interest, and often oversell the piece because, well, most people back down, and we don't want to let them go. This results in long discussions about the photographic eye, the process, the places you visit and the experiences you've had. Spontaneous buyers don't care about all that and may just cut to the chase and talk price. The worst thing you can do is push them beyond their comfort zone. Lead, but don't push.

which buyer is right for you?

To summarize the previous section, we've identified the art collector as being out of reach for most photographers. The other end of the buyer spectrum, then, is the consumer market, which involves selling images to product companies who sell them to retailers. For the purpose of selling prints for income (as opposed to "career development"), most photographers find that the best audience to target is the art aficionado, in all its forms. This doesn't mean that you won't find sales opportunities in the other categories, but when it comes to planning and investing in longer-term strategies, it's better to focus on the correct market segment for you and pick up the extra sales along the way if they happen.

finding sales venues

Public spaces, corporate offices, art fairs, festivals, cafés, and other places where you can set up shop are all candidates for direct sales. Such venues may not necessarily return sales right away, but the important thing is, they get you out there. I've learned a lot about the culture and the community of photographers at art fairs and festivals, and I've earned my ribbons and awards to the point of personal satisfaction, even though some of these events never returned profits. While only mildly profitable over time, the learning experience made it all worth it, and then I decided to move on. I know other photographers who've continued on this track, some of them doing quite well. But, make no mistake, even they acknowledge that it's a labor of love more than a source of money, and that they could probably do considerably better financially by stepping up their ambitions.

Getting started involves getting to know your community—the venues, the events, the people. Usually, the first place to look is in the newspaper or on the Internet for local activities. Art centers are a good source for finding photography events (which are often mixed in with other art-related affairs). Some places are harder than others to get accepted into, so the easiest way to start is by entering competitions. If your work is reasonably proficient, you can get noticed by a judge or two and maybe even get some ribbons. The best strategy for this route is "blind juried competitions," where the judges don't know who the artists are. Blind judging removes the disadvantage of competing with well-known names in the field who often get awards based on their reputations alone.

Also, it's not enough to just enter competitions; you have to use those events as public relations opportunities. Sending announcement postcards to potential buyers or individuals with whom a relationship would be strategic to your development is advisable. Be sure to invite owners of other venues where you'd like to exhibit your work in the future. Personally escort such people to see your work if you can. If you've won ribbons, even better. Marketing yourself well is about combining opportunities to create new ones, or leveraging one success to support another. And while you're focused on all that, you may be pleasantly surprised to find that aficionados have been picking up some of your pieces.

setting up for sales

I'm purposely not getting into what you need to buy or do to set up a booth or other sales fixture because there's a lot involved and describing the process here will not help you sell anything. This book is about strategy, not how-to details, which in themselves could warrant another book entirely. My advice for optimizing your returns, however, is to broaden your sales inventory to include more than just expensively framed prints. Your photos can sell in a variety of formats, ranging from unframed prints to small 4x6 frames, to postcards, etc. You might also share space with other artists to reduce costs while adding perceived size to your selling space. Again, attending events like this and talking to many artists (not just one or two), will give you a good sampling of what you can expect. This is also important because different geographical regions have different expenses and buying patterns that may help you ascertain how well your art fits into the purchasing culture.

buying art: criteria in making choices

Assuming you've found appropriate venues to display, exhibit, and sell your work, the next issue to raise is what you should sell and how you can best present it. You may think it's just about picking good pictures, framing them, and putting them up for sale. But, as anyone with experience will tell you, you will constantly be surprised by what actually sells. This is why it's important to know yourself, know your market, and know how you fit into it. Professionals often broach the topic of "what sells," assuming that buyers choose the "best" picture among a group (as if "best" were not a subjective determination).

Because one can find situations where anything sells, a more intelligent question would be, "How do people choose the art they buy?" And a sub-text question might be, "What decision-making processes do people go through when choosing?" Now we're getting somewhere.

perception of value

Our perception of value usually starts when we make our first financial mistake, like buying a cheap stereo component that breaks on the 91st day of the 90-day warrantee. Next time, given a choice between items that are otherwise identical, people often lean towards the more expensive one, or the brand name they recognize, or the well-known retail store with a reputation. There are many elements involved here, but people are usually wary of "the cheapest" item on the list. While price is an important element however, it isn't the whole story.

In this, and just about every aspect of commerce (especially in art), name recognition has this biggest affect on perception of value. People are willing to pay a higher price for a print from a well-known artist. This is the brass ring that we all strive for. Only well-known career professionals get to experience this, though, and by the time they have name-recognition, they don't follow the same sales strategies to move their artwork as the rest of us do. (This is one reason why following the advice of famous professionals may not provide applicable information for beginners.)

For those of us who cannot rely on name recognition to affect price or salability, we need to look at other factors that affect people's buying decisions. Because of art's intangible qualities, people tend to employ two different forms of analysis when evaluating art: comparative analysis and complimentary analysis. Let's discuss each.

comparative analysis

An example of comparative analysis can be found in the exercise of picking wine at a restaurant. People often opt for the wine that lies about two-thirds up the price list. Because most people don't know wine that well, their "perception of value" is often governed by heuristics learned from experiences buying other things (stereos, cars, groceries, or even art). That is, the lowest-priced item is generally the one to avoid, and the highest-price item is thought to be overkill. So, people generally make a selection that's just a little higher than the middle price. This makes sense considering that most people want a product that's "better than average" without paying top dollar.

complimentary analysis

Complimentary analysis is when "environment" plays a significant role in purchasing decisions. For photography, this can be a photo's frame, the room it's in, or even the lighting, all of which can compliment or detract from the work. In the wine example, the environment includes the restaurant, food, decor, etc. The major difference is that wine is often sold before the person actually drinks it, so the environment plays less of a roll than intangible value does.

Let's talk specifically now about how complimentary analysis applies to selling art. Have you ever gone into a gallery and expressed interest in a particular picture? The sales person may take you to a back room, hang the photo in a specially-lit location, offer you wine and cheese, and then fade the lights up and down to illustrate how the mood shifts dramatically in the picture's scene. (A wine shop won't do this to sell you a bottle of cabernet.) The "lighting trick" works, of course, impressing buyers who are unaware of the technique. The reality is that this effect works on just about any picture (although the technique is more often used with paintings). This is complimentary analysis in action.

So, now we see how comparative and complimentary analysis each play a role in selling art, and how they affect perception of value. Finding venues where you can control elements that contribute to the complimentary and comparative analyses works to your advantage.

How about pricing art? Curiously, the same two principles of analysis apply. For example, a photo priced at $1000 is less likely to sell if it's next to one priced at $100. The $100 piece, however, is more likely to sell for $200 because of comparative analysis. This is an oft-used technique for people who have no intention of selling the higher-priced item but want to raise the perceived value of the lower-priced one. By contrast, each picture in a series (i.e., a collection intended to show as a group) is often priced identically to the others, piquing the buyer's sense of comparative analysis. Studies have proven this time and again, which is why you rarely see non-comparable art works shown together. (By "comparable," I mean in the "perception of value" sense, not necessarily artistically.) To best sell and price your own work, you need to choose pictures that enhance each other in style, taste, and even value. Consider introducing a "killer shot" that's printed very large and displayed in an expensive frame to raise the perceived value of the lower-priced prints around it, employing the best of both comparative and complimentary value perceptions.

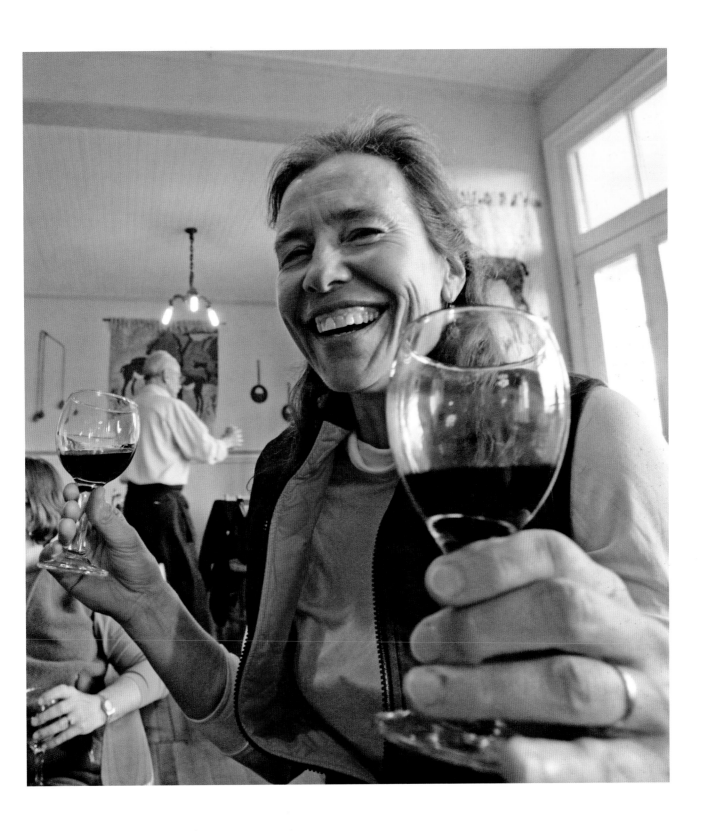

pricing prints

The most perplexing issue in any photography business is figuring out what people are willing to pay for art. Initially, I thought like everyone else: Start with low prices to generate interest, then raise prices as I become better known. I immediately encountered two problems with this strategy. First, lower price points attract a lot of tire-kickers, who require considerable discussion time, yet rarely buy anything. Second, sales don't make an artist "better known." Nor do sales spawn new sales—only marketing can do that. Becoming "better known" happens when you enter into the public eye in some other way. Having your photography reviewed by critics or exhibiting in important venues are two examples of this. There are many ways to become visible to the public, and this is entirely a marketing process.

To illustrate how I learned these two lessons, let's go back to the first couple of years of my photo career. I priced my prints low to attract sales, but this just turned into a sinkhole of time and effort. So much so, in fact, that I considered not selling prints at all just to stop those tire-kickers from taking up all my time while yielding no profit. However, instead of withdrawing completely, I figured I'd just raise my prices so that people would be less inclined to ask questions if they weren't actually considering a purchase. I raised the price for my smallest prints (8 x 10 inches) from $25 to $200, and I added bigger print sizes (all the way up to 40 x 60 inches) with ridiculously high prices. Ironically, I found that higher prices had quite a different effect than I'd anticipated. Immediately, the tire-kickers went away and, surprisingly, the sales started to climb. Unexpected, yes, but what was most interesting was how the demographic of my clients moved from the generic "consumer," to those who were more artistically inclined. They didn't bog me down with questions; they just bought prints. The average consumer is unlikely to spend more than $50 for a print, but those who are familiar with fine art don't wince at higher prices. Similarly, they don't ask the kinds of questions that consumers do because they already understand the market and, by extension, the product.

My initial miscalculation of pricing structures was evidence of my lack of knowledge of the very market I was trying to penetrate. There are other aspects of my sales strategy that had to evolve as well, not just pricing, which underscores my point that you need to be very cognizant of your own work and of your target audience.

If you are selling art through an agent, gallery, distributor, or other reseller, they are generally your best gauges as to how to price your work. But, be careful not to go to them for direct advice unless they are actually representing you. The mystery of appropriate price points can be as elusive to them as it is to you and me. Take any advice with a grain of salt.

signing and numbering prints

Many people who sell art feel the need to sign their prints, and most of these people also believe that they should number their prints, as well. It makes sense, of course, and artists are well known for their pride and care for their artwork. I don't have any objection to signing prints. However, it's really more an artifact of the class of buyer involved. For example, art collectors usually insist on signed and numbered limited edition prints, whereas no one else really cares. More surprisingly, I've found most people prefer that I don't sign or number them. This isn't an insult, it's just an aesthetic, but it depends on your audience. People who buy my prints have no idea who I am—they just like the photo and want a print. My signature just gets in the way. Perhaps if I got famous, I'd get more requests for my signature, but until then, my ego is not hurt over people not caring if I sign my prints.

There is another disadvantage to signing prints; it adds a huge chunk of time to the print order fulfillment process. When signing prints, I need to order the print, have it shipped to me, sign it, then re-package it, and ship it to the customer. This not only adds a step to the delivery process, but it adds a few more days and more expense, as well. What's more, if I'm out of town, I can't fill orders until I return. Because of these and a few other minor reasons, I no longer sign prints unless people specifically ask for it. (I do get requests from time to time, but it's more because there are some who feel a closer association with the artist when the print is signed, not necessarily because of perception of value.)

As for numbering prints, this is another aspect of art photography that is somewhat misunderstood by artists. The only reason to number your prints is to indicate that you will only make a limited number of a particular image at that size, and the only reason to limit your print number would be to enhance the value for collectors. This is only really appreciated if you are famous enough that there is a demand for limited edition prints. If you're not, then it's somewhat pretentious to number your prints. It's as though you're telling people that you think you're more important than you actually are. That said, it can be an effective marketing technique, and in business, this may actually be smart, though perhaps objectionable to those with more cultured senses (perhaps even yours). Still, there are as many pretentious art buyers as there are artists, so if a buyer sees that you sign and number your prints, they may perceive more value in your work than they would otherwise. (Sad but true: Many people become famous not because of objective opinions from well-respected experts and critics, but through their own clever marketing hype. I'll leave it up to you to determine which famous names fall into this category.)

Although the alert reader may sense the air of disdain I have for unjustified and unapologetic self-promotion, I do respect those who can actually pull it off. Indeed, such a technique may be most effective at fairs and other public venues where pretentiousness wafts through the air like the smell of popcorn through a movie theater. But, at the end of the day, you have to weigh this against the pitfalls; you may not fool enough people to make it worthwhile in the long run, and those you really want to impress (the smart art buyers or gallery owners) know better. Sending the wrong impression about yourself can work against you.

framed prints

Brutal art critics have said of the most famous paintings that the frame is better than the piece itself. Frames often have the effect of enhancing artwork beyond its own merits. Indeed, photography is no exception; nothing adorns a photograph better than its frame, so it's critically important to choose the most appropriate frame for your work. This is not a green light to get the most expensive or most elaborate frame (even if you're trying to showcase a mediocre photograph). This is especially true in the case of black-and-white photography—a classic case of "less is more"—where the print often looks best in the most minimal and modest of frames.

Framing styles and tastes vary dramatically. For example, a popular method is to use a very wide margin around the photo with matting that isolates the image as much as possible from whatever else might be around it (other wall-hangings, windows, doors, etc.). Similarly, people often opt for thick frames to establish an even firmer border. On the other end of the spectrum is the minimalist design, featuring very thin metal frames and extremely wide mats around very small prints. Color pictures make it tempting to choose mats whose colors match or contrast the picture inside. This can be quite effective for specific prints, especially those that don't share a wall space with anything else. Take a trip to any framing store and you'll see that the selections are so broad that your head will spin with ideas, all of which seem ingenious at first. And then you try a few.

For my work, I've eventually come to the conclusion that a simple black wooden frame and a plain bright white mat are best. I may choose an all white frame/mat combination, or all black depending on the context; in rare occasions, a thin silver metal frame can also be effective. Matting tends to be anywhere from 3 – 5 inches wide all around the photo (with an extra bit on the bottom). When matting and framing your prints, there are two important factors that you should keep in mind:

Consistency: Consistent framing choices for a set of pictures in a given environment provide a better sense of balance and intention. The scene as a whole looks less busy, drawing the viewer more to the pictures themselves. (Oddly, this doesn't work with paintings, which require almost an opposite approach.) With photographs, a lack of consistent framing can make a series of photos (or the interior design they're a part of) appear amateurish.

Portability: Using simple, neutral framing and matting (like black, white, or gray mat, and a wood or metal frame) allows photos to be used in any room in any house or office, and works with just about any photograph. This also makes it simpler for customers who are undecided about what they want. If a customer requests a framed print, I have the lab ship the print directly to my local framer, who frames, boxes, and ships it directly to the customer. Aside from an initial consultation about framing preferences, I am not involved in this process at all.

self-framing

Framing photographs is a time-consuming and difficult task, often requiring lots of physical space and supplies to boot. If you are making a lot of prints, then this may be worthwhile, but few photographers get to that point early in their careers. If you're just starting out and are interested in doing your own framing to save money, you're being penny-wise and pound-foolish. Your time is far more valuable than your money. Leave the framing to the pros and concentrate on building other areas of your business.

It is important to illustrate at this point that I only print, frame, and ship upon receipt of an order. I don't create ready-to-sell inventory. When I got started in the business, I printed up a number of pieces that I thought would sell well and placed them wherever I could—cafés, restaurants, dentist waiting rooms, and my dog's vet clinic. Although I've heard rumors of people selling lots of prints this way, I don't personally know any of those people, and it's never happened to me. (I've gotten calls to do other assignments, which is good, but that makes my efforts more of a marketing strategy than a print selling strategy.) To this day, I still have most of those early prints in my garage.

These days I sell over the Internet, so I don't have to have an inventory of framed pictures, which reduces my business costs. I realize that not everyone will run their business entirely on the web, which brings us full circle to the point of this chapter: To sell prints successfully, you need to find the right venue, the right audience, and sell the right product. Make your choices carefully, or you too may find yourself with a garage full of unsold prints.

odds and ends on framing

Glass vs. Clear Acrylic: Framers often advise using clear acrylic sheeting instead of regular glass because it's lighter and doesn't break as easily, thus making shipping easier, less expensive, and less likely to result in a damaged product. The catch is, though, that clear acrylic doesn't look as nice as real glass in front of a print, so I only use it if the customer requests it; I never choose it on my own. (Similarly, non-glare glass is like Plexiglas in that it alters the color balance and ultimately distorts the image. This is a tradeoff if the photo is placed in a highly lit environment where reflection might impact the viewing.)

Shipping: Because I print digitally through a professional lab, filling print orders is simple. When a customer places an order, I upload the digital image to a photo finishing lab's website and they turn around the print and drop-ship it directly to the customer (unless the customer requests a signed print). If it's an order for a framed print, I have the lab ship to my framer, who in turn ships the framed piece to my customer. My goal is to spend as little time as possible dealing with shipping. When you consider the time, materials, and other resources necessary to print and ship a product, this is one of the few occasions where I wholeheartedly endorse outsourcing. Since this is a rapidly evolving market, there will undoubtedly be an increase in the various options available for completing this process more efficiently and less expensively as time goes on.

For those handling shipping themselves, the first question people ask is: Which material is best for packaging a print? The answer varies on the type of print, its size, and the framing materials (if any). For unframed prints, the easiest answer is a tube. You can get these almost anywhere—the post office, the drug store, an express shipping outlet, or even a hardware or stationery store. Hard cardboard tubes are perfect; the print is never bent accidentally, and it's best for size, convenience, and versatility. What's more, multiple prints can fit in one tube. Most printer paper is easily rolled and unrolled and, to allay the

concerns of people who intend to frame these prints upon receipt, it is important to know that rolling the print will not compromise the framing process.

Some people like shipping prints flat, which is fine in principle, but it's bulkier, harder to produce a shipping-safe package, and is more susceptible to damage under unusual situations. Still, for smaller prints, I use a flat envelope and add cardboard to secure it. This is usually safe, and I've never had a problem. Seems obvious, but if you're feeling insecure, don't worry about it. It's just a matter of experience.

Shipping Carriers: I shipped using standard mail for years until the first time a print got damaged—there was no recourse because I didn't sign up for the insurance. While I've never had the post office lose a print, it has happened to other people I know. For this and other logistical reasons, I use an express shipping service (which the post office also provides). With some express shipping services, it may cost extra money to have packages picked up, so I tend to drop them off. All carriers are equally annoying for international shipments, but this isn't their fault—it's the nature of international shipping.

The carrier you use becomes even more important for framed prints, mostly because you've got more to lose, so you need more accountability. All vendors have essentially the same product so the real differentiator is customer service when something goes wrong. They all provide the same service, but how easy, fast, and thorough they are in dealing with claims is what set them a part from one another. When something breaks or goes wrong all shippers are at the low end of the satisfactory scale as far as I'm concerned. I've had bad experiences with extremely difficult, foot-dragging customer service when it comes to refunding money. Clearly though, everyone's experience will vary, and just because I've had bad experiences doesn't mean that you will. However, one major piece of advice I can offer is this: When you ship, go directly to the shipper; do not use an intermediary. If you go to a shipping store, they are the entity that has to file claims on your behalf, and the company that actually makes the shipment will refuse to work with you directly. The problem with this process is that the intermediary shipping store usually has no incentive, time, or even manpower to deal with claims. In short, they don't care.

summary

When it comes to prints, don't turn into a prima donna. You may love your work, but don't hold on too religiously to that feeling. What you actually sell may surprise you. The goal is to promote what you think is your best work, but realize that your second-choice pictures may be the ones that move. How close you get to selling what you think is your best stuff is contingent upon how well you know your audience. Why people buy artwork is as complex to discern as why they buy cars, music, or sunscreen. When you look at masses of people as a whole, however, you'll see patterns of behavior that you never would have expected.

POSTERS, POSTCARDS, AND CALENDARS

posters, postcards, and calendars

Here's an excerpt from an email that I received that might sound familiar: "I enjoy taking photos as a hobby and have done some beautiful work. I would love to be able to use my pictures on calendars and/or postcards, but I don't know anyone in the postcard business. What should I do?" At one time or another, each of us has had exactly the same feeling. It's a tempting prospect to shoot photos of beautiful landscapes, or cute pets and children, then sell them as postcards, greeting cards, posters, or calendars. But, as illustrated by the above email, it's hard to know how to get started.

It's not so much a question of whether it's possible, but rather a matter of weighing the pros and cons of two basic how-to strategies: One, find someone else to do it, or two, do it yourself. The crux of the problem lies in the fact that the costs for producing products like these are not much less than what people will pay for them. In order to make money, you need to sell quite a lot. Now, if you're thinking to yourself (as I did at one time): "I'm not that serious about making money; I just want to try." Okay, that's fine. But then the concern isn't about making money, it's about potentially losing it. It reminds me of a quote from one of my favorite stock market investors, Warren Buffet: "The way to make a million dollars is to invest a billion dollars in an airline."

What major airlines and small-priced commodity products have in common is that they both require a lot of time and money just to keep from losing your investment. And you can't just do it in small doses. It's like feeding an elephant; you can't decide to only feed it "a little bit" because you don't want a large animal in the house. You either sign up for the elephant, or you decide to get a dog. The commodity product business requires time and attention, or else you'll end up with a large mound of postcards in your garage. However, it can be done, like anything else, if you go about it intelligently. So, don't let me talk you out of it... yet.

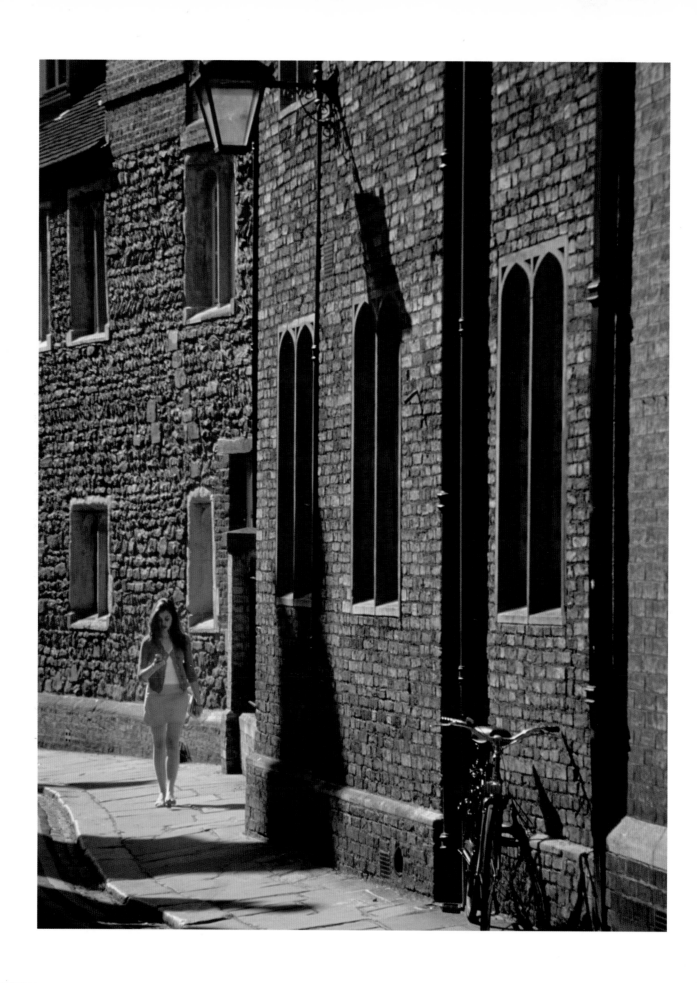

the quick answer

There are three steps that you'll go through when entering into the postcard, poster, or calendar business:

Sell the products yourself. Keep in mind, though, that once you go to the effort of printing and finding shops to carry your products, you may think it's gotten too costly, time-consuming, and frustrating. Go to Step 2.

License your photos to a publisher who's in the business already. This is a challenging effort, and while you may occasionally find a company that licenses an image or two, you'll learn so much about the inner workings of the business that the remuneration they offer has you reconsidering Step 1.

Lather. Rinse. Repeat. You can swap back and forth between Step 1 and Step 2 for a long time before you get a sense of which is really the better option. In so doing, you'll eventually settle into the one that feels more right to you. It's a classic case where the grass is always greener on the other side. Which side is actually greener depends on your finally nailing down what it is you want from photography (which is probably where you should have started this process in the first place).

Getting back to basics, the secret to making a postcard business succeed lies in one word: distribution. The cost of making postcards or calendars is so close to what people are willing to pay that the profit margins are slim—especially after you factor in unrelated costs. The only way to reduce overall cost "per unit" is to print a higher volume. Here's where distribution comes in. You need to move your product through a distribution channel—a set of outlets (sales reps or stores) willing to carry your product on an ongoing basis. This requires keeping in touch with them, checking on inventory, filling empty slots with new products, determining which products aren't selling, getting clients to pay their bills, apologizing for missing last Tuesday's appointment, and acknowledging that your idea for last year's Christmas card,

"Santa Gets Sued," might not have been a great idea. Some people find this process very enjoyable. I'm not being satirical—it's true! And there's no shame in it. This is a very people-intensive business, and those who thrive best are those who love engaging socially. As long as you are clear in your goals and ambitions, achieving them will be easier and more enjoyable. If you're not eager to do a lot of legwork, you need to find other people who'll do it for you. So, as you discover your tolerance for different aspects of selling photography commodity products, you'll vacillate between Steps 1 and 2 until you find your groove.

the long answer

Ah, you're still here. Well, if you're still reading, I suppose I haven't scared you off yet. Good, because I never want to discourage the entrepreneurial spirit, and there is an opportunity for anyone that has the wherewithal to go through with the effort to have a tidy little postcard business. Or, if you don't care about making much money and just want to have fun making cards for friends, relatives, and little corner shops in your neighborhood, that's great, too. You'll probably break even and get lots of praises. Whether you do it yourself, or go to another company to sell your work, there are two main barriers to entry in the postcard/calendar market that you'll immediately run into:

Competition: There are millions of people trying to do the same thing. Professional photographers aren't the only ones that take great pictures. Amateurs have really good ones too, and although they may not take the business as seriously as the pros, their sheer numbers make them formidable competitors. Photo buyers, whether they are publishers or small gift shop owners, have to sift through so much material that it's hard to get to the good stuff, let alone yours. The irony of all this is that, despite the amount of images to choose from, there ends up being a large quantity of poor material for sale. This explains the next barrier...

No Accounting for Taste: While I'm sure you are convinced that your photographs are superior to everyone else's, everyone else thinks the same of their own work. So, in a world where everyone's pictures are great, what matters is the taste of the buyer. The business people who get to decide what's salable and what's not have limited time to spend focusing on this one aspect of their business. So, they have to optimize what little time they do have, which often results in quick decisions that "regress towards the mean." That is, they end up making "safe" choices—pictures that are similar to other products that have sold in the past. (We'll talk about how this concept affects your own decision-making a little later.)

One photo editor actually told me, "Even if I find something uniquely different, I look at statistics: It won't sell any better than the usual fare anyway, so why take the risk?" Okay, it's not quite that depressing. When pressed, the aforementioned editor also acknowledged that it is great to find something new and unique, but it's not a goal that they go out of their way to achieve. Cards that don't sell can drag on profits quickly.

Working with shop owners is much easier; they don't get approached by photographers quite as often. They will usually take more time to consider your work, but you'll still face stiff competition, albeit from a different source—the postcard companies. Shop owners order batches of products in bulk from the big suppliers. Now, we're back to a case of the grass is always greener on the other side. Sometimes it seems easier to get into a store if you go through the publishing channels. One advantage you may have with the shop owner is "local color." Chances are slim that major, nationwide card companies are going to provide a whole rack of scenics from your local landscape (unless you live in a national park, or a major tourist city). The "local color" factor may be a potential "in" for handling it yourself.

Now that we've addressed the barriers to entry, let's discuss the options more closely. First, we'll address approaching product companies, then we'll discuss doing it yourself.

approaching outside distributors

Despite the difficulty in approaching card companies, it is possible. In fact, the process is simple.

To approach a distributor:

Go to a search engine and type in "postcard companies." You have a huge supply of postcard retailers to choose from. If postcards aren't your thing, pick your product (like calendars, for example). The process is the same.

Contact the photo editors. Ask them if they are accepting new photo submissions, and what their submission guidelines are.

See? It's simple, just as I said! However, I didn't say you'd be successful at it. The hurdle to clear during this phase is the photo editor. (If it's a larger company, it's the assistant photo editor.) This person's job is like the goalie in a soccer game—keep the photographers out of the net. Before you even get to other questions, you'll probably be told that their list of photographers is long, but that they are always interested in seeing fresh new stuff, so you should send it in. "However," the editor continues, "your chances are limited." You'll be encouraged to send material, but discouraged from expecting that anything to come of it.

Here's where you can turn this to your advantage: Ask what percentage of submissions they accept? How many images do they usually take from a photographer? How often do they use the same photographer's work? These questions will all help you learn what it's like on the other side of the fence so you can set your expectations properly. If you're getting good, candid feedback, find out what the pay scales are like so you can know what it is you're missing (or getting yourself into, if you're lucky). What are the payments like? What kind of returns are their "best" photographers getting? What about the "average" photographer? How about if they were to take even one image a year?

If you're still at it, probe further; try to get a characterization of what their typical photographers are like. Are they full-time pros, or average people that send in good shots here and there? You want to know who you're up against. If you get vague responses, like "They're all over the map," then you'll see that you're really just playing a lottery game.

No matter who you are, everyone (even the top pros) dramatically underestimates the vast amount of work, time, and (yes) money required to get images in front of a photo editor's eyes. The costs often come in the form of making portfolios—many of them—each better than the last, all in an effort to make an even better impression than before. If you get your photos selected, set your expectations low. One or two is typical for first-timers. Three or more is unusual. How much you get paid is another question entirely. You might believe that "money is not the issue" since you just want to see some cards made out of your nice photos. But, by the time you've gotten to this point, you may feel differently.

Oddly enough, you may find that what you've done is build a small stock photo agency, and your opportunity to get published would be much greater if you'd widen your horizons beyond just cards and consumer products. This is why it's very rare to find photographers that sell exclusively to card companies. Most have more generalized photography businesses, where a small percentage of sales happen to go to that sub-segment of the market. Accordingly, most companies that sell these products select from a wide cadre of photographers. I'm a good example of that; I've sold many images to postcard and calendar companies, but they account for a small percentage of my overall business, just as I am but one of hundreds of their photo suppliers. While some photographers have gotten their "in" by approaching such companies, they are a very small percentage of those who've tried.

If by the end of this exercise you feel compelled to continue, then you have a stomach for the business in general, and I'd say you're a prime candidate to sustain a serious photo business rather than simply focusing on cards. It may be that you start in this area, and I would encourage you to continue. My dim forecast for success is simply a mildly unsettling honesty that must be expressed, if for no other reason than to offer some realism to people who might otherwise start out with unrealistic expectations. The bright side is that those who do have realistic expectations don't see my characterization of the industry as "dim" at all; they find it refreshingly challenging. If you find it's not for you, consider...

home-based distribution

Producing and selling products yourself is fun and rewarding, but it requires a concerted effort and smart financial planning. Depending on the particular kind of product, timing is also a factor. For example, calendars are the hardest to sell because the window of opportunity to sell them is limited—usually, between October and December. Whatever doesn't sell during that timeframe is lost money. Posters are similarly difficult because they are physically bulky, requiring higher production costs and considerably more space in a retail outlet to sell. Thus, fewer outlets sell them, opting instead to sell higher profit margin (and higher volume) products, like greeting cards. When targeting outlets that do sell posters, go to a poster shop at your local mall and ask the manager what subjects sell best. (This will be an eye-opening experience in itself.) The market for scenic posters is more limited than photographers would like to believe. That said, it can be lucrative if you've already had some success selling cards within that certain target market, which leads us to the crux of the discussion: selling greeting cards and postcards.

The major challenge with these products, cards included, is the rule of thumb I mentioned earlier in this chapter: Production costs are not much less than what people will pay for the product. To keep from losing money, you have to sell enough cards to at least cover the cost of production and the expense of getting them onto store shelves. The cost goes down as quantity goes up. In fact, if you were only to print up a small quantity of cards, you'd actually end up paying more per card to produce them than what people are willing to pay to purchase them. So, you have to print in higher quantities to get the prices low enough that the retail price brings in money (or keeps you from losing money). This "higher quantity" usually translates to 2,000 – 3,000 cards, and that's just for one shot.

If you're going to sell cards, you have to sell more than one image and you'll need at least 25 – 50 stores selling your work. So, the first thing to do is to see if there are even enough places that can sell your cards. If you haven't already done so, spend some afternoons visiting stores in your area to get an idea of what's out there. What kinds of stores sell cards? Gift shops, of course, but also pharmacies, grocery stores, gas stations, etc. The options may be limited or great, depending on where you live. (If you're thinking of producing and selling cards strictly online to eliminate the distribution model, start by reading pages 134-157. Selling on the web requires getting traffic, which is another kettle of fish all together.)

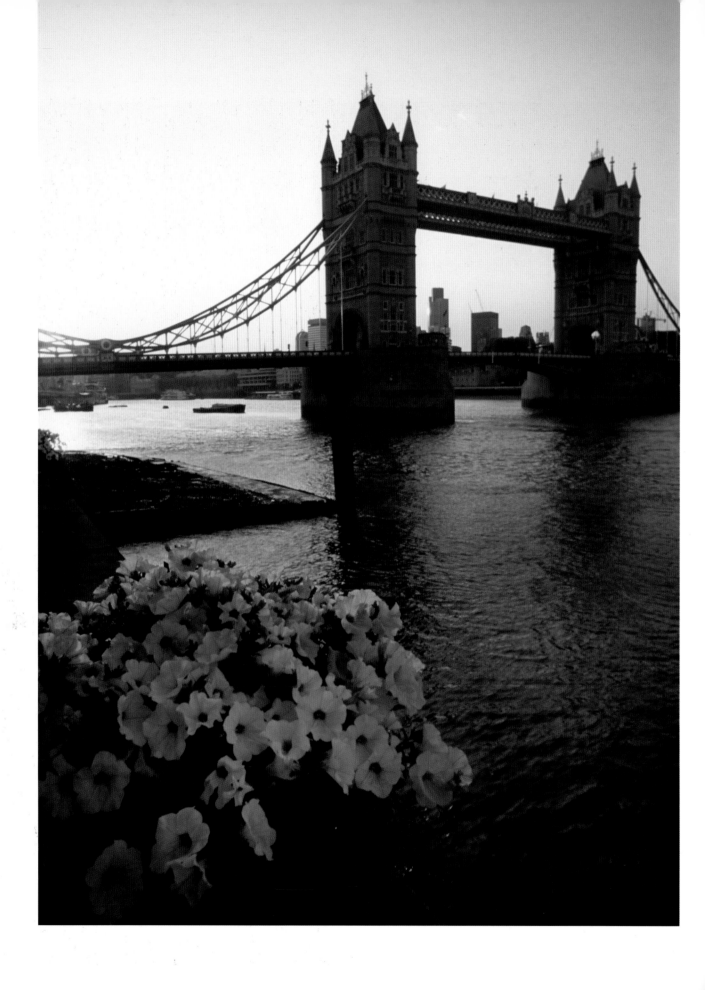

Greeting cards (which typically fold and have envelopes, and whose sizes are either 4 x 6 or 5 x 7 inches) usually sell between $2.00 and $3.50 per card, depending on variables like size, store location, photo subject, and the physical materials of the card. Talk to store managers and ask which cards sell well and which don't. You will invariably hear how they were initially surprised at the results, both positive and negative. (Again, there's no accounting for taste!) You don't want to end up with a garage full of unsold cards, so you need to go about this intelligently.

The variables in your control are:

The photograph (as well as optional text inside, if it's a greeting card).

The type of card (greeting card, postcard, its size and materials, etc.).

The places you choose to sell (or rather, the shops that sell for you).

The production costs and other business matters.

Selling postcards and greeting cards isn't like the art market. (See page 99 for a discussion on determining what kind of art sells and who buys it.) In this context, your target audience is the "consumer." As general market data proves over and over, anything seems to sell well to consumers if it's positioned, packaged, and priced just right. And there's no point in discussing specifically where to sell your wares because only you know your local market. At this point, it's a matter of choosing your business model: which image, which format, and how to manage production and distribution.

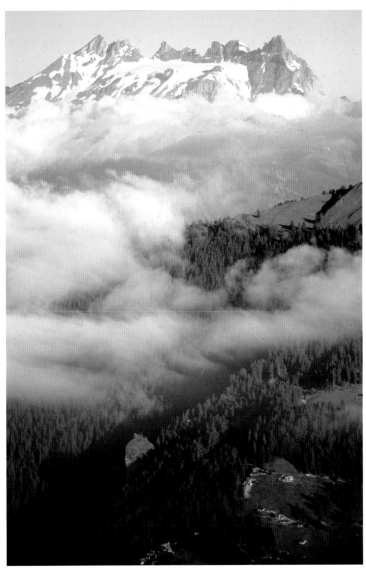

making and
selling cards

There are two ways to produce postcards or greeting cards. You can make your own, or have them professionally done. But that's not all it takes! There are important time and cost factors to keep in mind, no matter which production method you choose.

homemade cards

Making your own cards requires getting a bunch of prints made at your local photo lab, then gluing them to greeting card stock. As for the card stock to attach it to, search the net for "greeting card stock" and you'll eventually find prices for quality products that range from about $.50 to $1.00 per card. You can make some extremely attractive and professional-looking cards this way—I've seen some card stock from a classy stationary shop that cost up to $2/card, but these can sell for $6 each in the store with your pictures on them. Keep in mind that the higher the cost, the more considerably the volume drops (both in sales and production), which eats into your margins. The tradeoff between high-margins and high-volume is not an easy nut to crack for any business.

As for envelopes, you can usually buy them at the same place you get the card stock. Put them all together with your photography and you've got a generally salable product. Getting your cards to retailers may require extra packaging, but that's just one of the details that you'll run into as you go through the process.

professionally-made cards

The other way to produce cards is to have them professionally made. I have used many card-manufacturing companies to produce a variety of card styles, gift boxes, etc. Thankfully, most of these were produced for clients who used them for invitations, holiday cards, and other uses that aren't always for commercial resale. For this reason, I've had the opportunity to learn many of the lessons of production without personally assuming any major investment risk. Believe it or not, the cost of having cards made professionally yields about the same profit margin as making them yourself.

As for advice on choosing a printing company, I'll offer my usual word to the wise: Printing and customer service vary dramatically, so don't just go with the cheapest provider you find on the Internet. Printing companies will send you a sample kit of products so you can see what yours will look like—you don't need to shoot in the dark.

getting down to business

Let's assume some numbers to illustrate a real business scenario. For this example, we're going to produce ten different 4 x 6-inch greeting cards for distribution to ten stores in your local community. If you're going to have a rack where each photo has a stack of ten copies, that's 100 copies of each photo to cover all the stores. Using either manufacturing method (do-it-yourself, or pay a professional), if it costs $1.50 per card to produce 100 cards, that's $150 per photo, times ten stores, which adds up to $1,500 just to make the cards. Stores often take 50% of the retail price, which is where the reality strikes. If the card sells for $3 and you only get $1.50 back, you're only covering your expenses. In other words, you're spending $1,500 just to get it back... and that's assuming all your cards sell. The reality is that, until you establish which of your cards sell well, you may only be selling a fraction of your inventory. (This leaves you with unsold inventory that starts piling up in the garage or basement, plus a sales deficit that you promised yourself you wouldn't incur.) The fun isn't over yet—you have to replace those losing products with new cards, and you don't yet know whether they'll sell—basically, you've got a whole new set of expenses before you've even made back what you initially invested. The goal of this repeating procedure, of course, is to gradually diminish the cards that don't sell and replace them with cards that do. But by the time you achieve that, you might as well have spent that money on a weekend in Las Vegas and tried the slots. In other words, there are more intelligent ways to go about this.

If you're thinking that postcards are less expensive than greeting cards and would yield a higher profit at lower costs, it's true, but only marginally. You still have the same formulation as above, just with different numbers. The retail price of postcards ranges from $.35 in very inexpensive areas, to $1 in high-traffic tourist locations. So, let's say you sell yours for $.50 per card—the retailer gets $.25, you get $.25. Since it cost you $.16 per card to make, you're left with a profit of $.09 for each card. As with greeting cards, you'll soon find that some postcards sell well and others don't, and the same economic formula applies.

doing it the smart way

The previous example illustrates how both direct and indirect costs add to the risk of investing in a business model that you don't yet know. How do you minimize your loss while optimizing return? The traditional answer is to observe the obvious; per-card prices drop with higher quantities, but reprints are even less expensive, which makes card resale far more profitable. So, what you really want is to "jump" to the point where you can just have your proven images selling well so you're printing and supplying mostly reprint orders, where the profit margins are very high. How do you get to that point without losing a lot of money? Here's the counter-intuitive answer: Be willing to lose a little bit of money.

Here's the logic: Instead of printing 100 or more of each card, only print twenty of them. Instead of $1.50 per card, the price goes up to $2.20, but you're buying 80% less. Instead of targeting ten stores, target one or two—again, 80% less that you're paying out to retailers. Your goal at this stage isn't to make money, it's to lose as little as possible so you can figure out which products to really invest in later when you go all out. Sure, you are guaranteed to lose money this way, but it's a controlled loss, thus limiting your downside. Now, instead of investing $1,500, you're only investing $440. In real numbers, you've "saved" about $1000 and learned a very important and potentially profitable lesson—which products sell well, and which don't. As you gain this information, you can then widen your production and distribution ratios, aiming to get to that coveted position of just refilling existing stock with much higher return margins.

Going at it "the smart way," as detailed in the previous section, is just an example to illustrate one way to test your market while limiting your risk. Your actual numbers may vary quite a bit from this example, but the concepts remain the same. You might even use the same "test market" technique to experiment with new images while you're expanding your sales of the ones you known will do well. This form of "interlacing" is how you use the profits from proven sales to finance the development of new products. It takes experimentation to know for sure which of your photos will work with your particular market, and also to really know the demographic of your audience. It takes an investment with a potential loss to gain the confidence to make a bigger investment. (Hey, remember those calendars and posters I talked you out of earlier? Now may be the time to try them out with less-risky images that you have determined will sell well!)

Coming full circle, if you're successful at doing this, there's a very high likelihood that a major card publisher would be extremely interested in not only carrying your work, but even acquiring your business! This is why it's wise to make sure that you set up a solid ground for your business endeavors, as well as have some idea of what your goals are and what you hope to accomplish. (Refer back to pages 22-39 for a review of how to start up a photography business.)

summary

Independent of all these factors, the real lesson you'll learn in opting for the "do-it-yourself" method is what it's like to be a distributor. If, in the end, you figure you might as well work with an established postcard company that already has inroads into doing this exact same exercise, then we've circled the discussion again. The grass is always greener on the other side. Despite the challenges you'll face in this business, the often-overlooked benefit is not financial return, it's accomplishment. Add to that the feeling of doing something productive with your art, and you'll find potential value that shouldn't be discounted. Still, to do this without breaking the bank requires good research and thinking ahead.

9

HAVING A
PHOTOGRAPHY
BUSINESS ON THE WEB

having a photography business on the web

In this era of digital imaging and information technology, a presence on the web is absolutely mandatory. Whether you present a simple portfolio page with contact information or a full-blown storefront, you've got to make use of the web—not using it can hurt your business. Imagine going to a doctor who doesn't believe in X-rays. That's how most people feel about photographers who don't have a website. Depending on the type of photogra-

phy you do, the web may play a larger or smaller role. For some, it may only be a business card or a portfolio; for others it can be an entire online repository where orders are filled.

This sword cuts both ways, however. While the advantages of a personal site can be considerable, following a poor strategy in implementing an online presence can be costly in time, money, and lost opportunity. So, it's imperative to understand your objectives ahead of time. This doesn't mean that you have to know from the beginning exactly how your site is going to look and function, it just means that you need to know what each stage of development involves before you get started. Things that appear simple at first can often become overwhelming, so try not to bite off more than you can chew!

This chapter is not a discussion on the technical aspects of how to build a website. Entire books have been written on that subject, and research will yield many valuable titles. A word of caution, however: Be discerning in examining your sources. More specifically, be wary of looking at the sites of other pro photographers as a model for your site, as this methodology can be fraught with problems. First of all, most pros who have nice-looking websites may not necessarily be doing good business there. Secondly, more often than not, successful photographers became well known before the days of the web. By the time they implemented a web presence, they already had an existing business infrastructure that could finance the effort, as well as photo assets and name recognition, which are the real money makers. Most photographers who write books about using the Internet fall into this category. While there's nothing wrong with that, they often pitch themselves as having secrets to success that really don't exist. Also, keep in mind that photo businesses vary dramatically from one to the next, and there is no "one-size-fits-all" methodology for them, or their websites. The web is an inherently difficult and volatile business model, and one cannot be taught proven strategies that can be simplistically mimicked. As my favorite saying goes, "If it were that easy, everyone would do it."

A better way to learn how to build a website is from sources that are not trying to sell a business model. Books that teach about the technology and the paradigms behind the web are the most useful because you can apply them to whatever business model you're developing.

first steps

Let's start by addressing the most common questions people have when they consider using the web for their photo business.

As you may suspect, there are no static answers to these questions. There are no formulas, no quick equations, and most of all, no empirical data to support the existence of sweeping design formats that are proven to create a successful website. Therefore, one person's experience should not necessarily be held up as a model for others. That said, there are subtle guidelines emerging from a number of different industries that show certain design elements as being more effective than others. Like any new science, it's easier to identify what doesn't work than what does. Just a few short years ago, strategies such as mass emailing and other unsolicited broadcasts were thought to be the best techniques for drawing web traffic. These are now disproved. The challenge is to find successful techniques and then to utilize them in combination with your particular business type. Such analyses must be individualized for each photographer. Professing a "formula" for success would be like selling snake oil. This may disappoint those who seek quick and easy solutions, but if you read this chapter carefully and thoughtfully, you'll begin with a more solid foundation.

First, the premise of your site is not like that of amazon.com, where most people already know what they're looking for and visit with an intent to buy. The exact opposite is true for most photography sites; a high percentage of viewers stumble upon them unintentionally and may stay a while to browse. For the most part, these viewers are not in a buying mood. While they may make an impulse purchase from time to time, it's an exception and you should not depend on this behavior to generate substantial sales. Most importantly, you can't push people into a purchasing mindset by designing your site with a pushy selling style; that will only turn people away. Worse, you may deter potential clients who want to license images or hire you for an assignment.

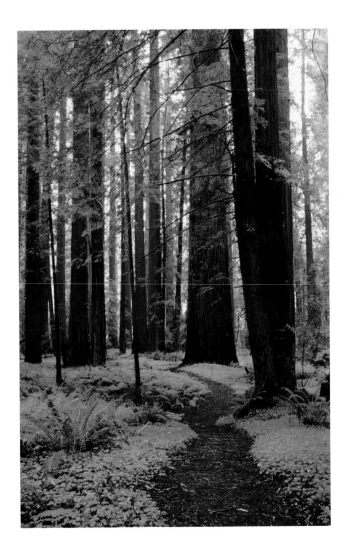

The time it takes to get your site up and functional depends on how elaborate you want it to be—will a basic portfolio suffice, or do you want full picture-selling capabilities? Either way, your first job is to get your photos online and, fortunately, this is quick and easy work you can out of way early on. Once this stage is complete, you can then reexamine your web strategy as your business evolves. It can take a day to get a basic website that has your name and required information up and running, but it can take years to have a full-fledged shopping site. The wide business spectrum in between will come in stages. So, let's start by tackling this first objective: getting pictures online.

join existing photo-enthusiast websites

The simplest way to get your images online is merely to use existing websites that feature the work of photographers. Here, you aren't really building a site at all; you're just getting your images onto other, more established sites. This means that you must either have your images in digital format already, or a plan to scan film.

Since most websites give you a platform to customize and populate your area of the site with photos and contact information, these sites are "good enough" for even the most skittish beginner. Most are free to use (you only need to register), and range from well-known Internet names like Yahoo, to more focused sites like www.photo.net and www.pbase.com. There are other specialty sites as well, for wedding photographers, portrait shooters, fashion photography

(for both the photographer and the model), and so on. A simple web search yields many options. The two drawbacks to using these kinds of photo-enthusiast websites are:

Customers will not find you: While you may get a lot of visits from other photographers that also share the site (and it's rare that photographers buy others' work), no one else will find you (i.e., customers). Most traffic that comes to a typical website results from keywords searches submitted to search engines. Unfortunately, search engines do not index photo sites like these, so people looking for pictures online are not likely to find yours.

You can't sell your pictures: These sites are designed for photo enthusiasts, not business, so you're not going to appeal to the typical photo buyer. Not only will the appearance be non-business-like, but you won't have a business infrastructure, like a shopping cart system for taking orders.

Neither of these "drawbacks" is a bad thing, by any means—these sites aren't designed to be anything more than a forum for photographers. And that, in fact, is their main advantage. This is where you learn the basics, but you'll still have to spend a lot of time marketing yourself through more traditional, non-web-based methods. How you do that depends greatly on the kind of business you're running. A wedding and portrait photographer might do better at advertising and generating business through newspaper and phonebook ads rather than through a website, but that doesn't alleviate the impor-

tance of having a web presence. In this example, a website would be used as a sales support mechanism. Customers that see your newspaper ad may want to look to the Internet for further information. As you can see, if you don't have a site, or any sort of web presence, this can work against you even if you're using other forms of advertising.

Whatever you do, I strongly advise against putting your images up on websites that implicitly require you to grant "usage rights" to the company that's hosting your photos, unless you are given some sort of commission in return. That is, some sites will use your images for commercial purposes and give you a commission. While it's a great idea, the business model is unproven as yet. That said, I've got my eye on the trend—it could be promising. I've seen a number of sites emerging that sell cards, and other trinkets that have photos in them, and pay the contributing photographer a royalty based on the number of images sold. You should read the license terms of any given site before joining up, and also probe discussion forums for independent accounts from others who may have had experience with the particular site.

A similar (but not entirely identical) brand of website is the photographer community website. Again, the usual suspects are well known and highly visible, such as Yahoo Photography Forums and Microsoft Photography Forums. There are hundreds, perhaps thousands more, and they come and go as rapidly as the Internet evolves. You should always use a good search engine to find sites that suit your tastes. As with the photo-enthusiast sites, there aren't any shopping cart features that allow you to sell the photos you display (though you can always solicit business by encouraging people to email you), but the real benefit to the "community" sites is that you can interact with other photographers through discussions, question/answer forums, and photo critiques. (In fact, even if you don't post your own photos, these sites are still good discussion and information outlets.) As is always the case with online communities, be a critical thinker. Not everything that everyone says is gospel, or even necessarily true. You are advised to spread your time among many different forums for the broadest set of possible truths.

basic online sales

While most photo community sites do not provide features that help you sell your photos, there are some exceptions, one of which is www.shutterfly.com. This site, as well as some others, allow you to sign up as a "professional photographer" (which requires an application and approval process). Once accepted, you can then upload your photos and set your own prices on prints. You can direct people to your gallery through the site, and visitors can place orders for the size and format of each print. The advantages are clear: You don't have to build a website, and you don't have to be part of the ordering, printing, or delivery process. Customers pay shutterfly.com directly, as the company prints and ships the orders. You'll get your check after each month's worth of sales. (This applies to prints only—they don't handle licensing of photos.)

All sounds good right? Well, there are drawbacks to using sites that do this sort of thing. The main problem is that these websites are designed for one kind of shooter: the "event photographer." For example, if you just shot a wedding, you could upload your pictures to the site, then tell your clients to go there to order the prints they like.

You don't have to do anything beyond that. Unless you're that kind of shooter, however, the usefulness of these sites is limited. That is, unless specific clients are told to go to a specific page, no one will ever find your images. Customer service can also be a problem; it's really designed for consumers, not pros, so you're not going to get the kind of attention you may need to help your customers if there's a problem.

outsourcing web development

Eventually, you may find the above options either too limiting, or inappropriate in other ways, which means you'll need to have your own website, complete with your own domain name. There are two ways to accomplish this: Do it yourself, or hire someone else to do it. The decision here has everything to do with time, control, cost, and end-result. That is, are you really designing a complex shopping site, or just a platform to display your photos and contact information? If it's the latter, then in this day and age, personal websites are easy and cost-effective to do yourself. You can use them for business as well, but here's where the trade-offs begin to emerge: The more you want the site to do, the more technical and complex building it becomes. If you get beyond your own technical skills or interests, then you might want to outsource the job to a web designer. But buyer beware—this path comes with some risks. Namely, photographers tend to be artistic, and so do web designers, and if both of you want to highly control the process, it's a recipe for disaster. You may think you want to step back from the process and let the expert do his work, but what ultimately happens is that the business owner wants to direct the designer like a cab driver: "You do the driving, I'll tell you where to go." As is always the case, the first part of the job goes quickly and smoothly because it's just a matter of setting up basic foundations (i.e., the site's structure and basic functionality). This is why outsourcing the job is adequate for photographers who do not depend heavily on the web, or who don't need to update it often. But, anything more than that, and you will probably find that finer details become increasingly more important, requiring more of your time and attention to oversee development.

Eventually, there comes a crossover point where you have to decide whether you're actually saving time and money using an outside developer, or whether you should do it yourself. In the spirit of the step-wise approach to developing the web part of your business, it may make sense to hire an outsider for initial groundwork, but you should consider that you may eventually want to take over. How soon that happens is more dependent on your technical aptitude, or your willingness to develop it, than anything else.

building your own website

Building your own site, even from the ground up, is not hard anymore. Nor does it necessarily have to cost a lot. In fact, most Internet service providers (ISPs) give you web space and tools to create web pages as part of your service agreement. If you go to your ISP's home page, you'll probably see a member login link where you can find information on how to create your pages. America Online (AOL), for example, offers three options, including their "1-2-3 Publish" tool (which is mostly a fill-in-the-blank series of forms), as well as their "Easy Designer" package that's slightly more sophisticated (it offers a set of design templates).

Similarly, EarthLink allows its users to create free webpages with a tool called "Trellix Site Builder," which runs within your web browser. Again, you select from a series of design templates, including some that are geared towards small businesses.

There are also many places that will host your site for a monthly fee, where you can choose your own domain name. I recommend using a name that's easy to remember, and especially one that's associated with you. I chose to use my own name (danheller.com), simply because it's the easiest way for people to remember me. This may not work if your name is hard to say or spell. On the same note, people with extremely common names may find their name already in use. In these cases, you have the arduous and frustrating job of finding a good, creative name to use as your website. This can take many days of pondering before you're happy with your choice, so get started soon.

As great as they are for initial setup, there are barriers to how much basic templates can do, which may lead you right back to the web-designer. But, before going into an endless loop of if-then-but circles, you may consider biting the bullet and just learning a web-design tool yourself. There are plenty of professional level tools that let you build websites from the ground up. Macromedia's Dreamweaver, Adobe's GoLive, and Microsoft's Front Page are all typical examples of such tools, and are probably the most common for those who build webpages, whether they are professionals or not. The webpages that these programs build can be uploaded to the same web space that your ISP gives you, or that you "rent" from some other hosting company. Choosing which product to use to develop these pages, however, is a matter of research and testing. Technology is evolving way too quickly to rely on this book, or any other static informational source, to have the most up-to-date information, so your research should include learning what other photographers have to say about any given product. (Refer back to pages 140-142 for more information about discussion forums.)

My summary point on web design is this: The time and attention you give to your website should be directly in proportion to its importance to your business. In other words, never hand over critical business tasks that generate income to others. Things like tax and legal issues are not revenue-generators, so that's different. If your web space is part of how you generate income, you will eventually have to do it yourself. If it's just a portfolio, having someone else build it is fine.

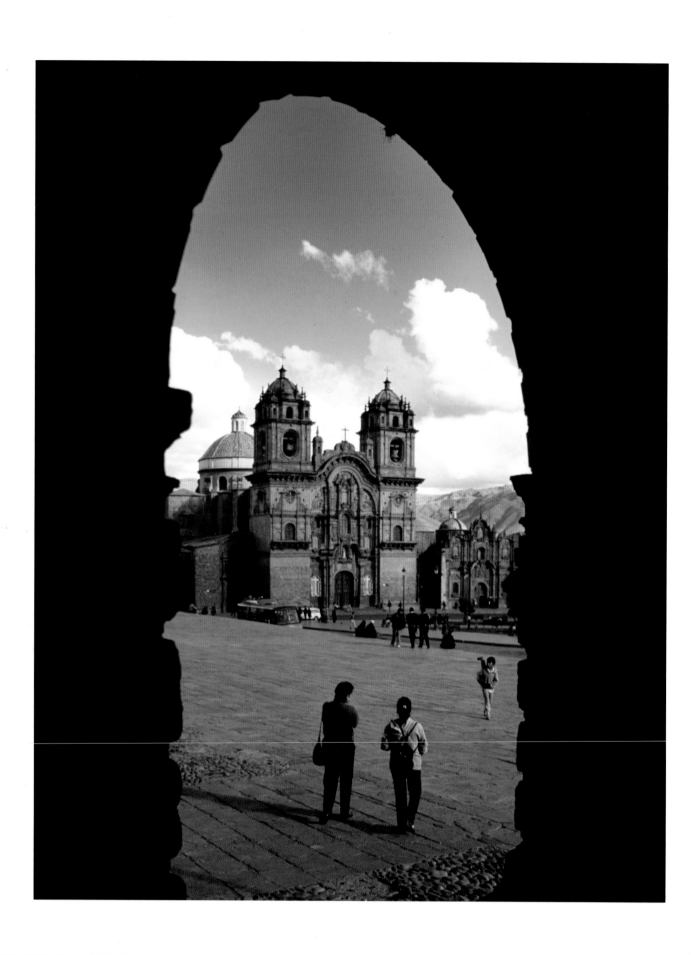

deciding on design and content

Numerous books have been written on the various tasks of web design, and many more will be written before you're done reading this book. Most are very good in covering general design aspects and technical details, but none that I've seen have specifically addressed the niche of a photography website. What may be good design for some (or even most) sites may not necessarily be appropriate for a good photography site. In that spirit, here are some fundamental guidelines for your website and your Internet presence:

Keep the Quality of Your Images as High as Possible: Since we're talking about a photography website, it's just plain obvious that bad images will degrade the experience of any potential customer that goes to your site. Deciding what constitutes a good or bad image is the hard part because it's entirely subjective; there's no way anyone can figure that out for you. However, the underlying issue is salability: Which images can be sold? (See page 96 for more about selling photographic prints.) Remember, you yourself are solely responsible for which images you think are good ones. How good your self-assessment is will ultimately be revealed by your sales figures.

Quantity is Just as Important as Quality: Populating your site with as much good content as you can is critical. The more quantity you have, the more content search engines have to index. This translates directly into more traffic. But, the more quantity you have, the more important quality becomes. More of a good thing, in this case, is good. But more of a bad thing can be disastrous. So, beware of throwing a lot of random content on your site just because you have it.

Use Reasonable Image Sizes: More people in the USA use high-speed Internet access via DSL or Cable Modem than dial-up. What's more, serious buyers are usually in companies with even faster Internet access than home users, so "reasonable image sizes" are bigger than they used to be. The days of designing sites optimized for

low-speed modems are gone. The size of the thumbnails you use for low-res images don't have to be all that small, but they shouldn't be big either, especially if they're together with other images on a single page. The issue is a matter of site design, not the speed in which a page loads. You can dilute the quality of a page if you make it too busy, just as you can under-whelm the visitor if you give them too little to chew on.

Navigation Should Be Easy: You'd be surprised how difficult it is to come up with a design that makes it easy for a complete idiot to use a website. Often, visitors don't read instructions, see the menu bar across the top of the page, or realize that an icon does what should be painfully obvious. There are some de-facto standards, such as using a shopping-cart icon to represent a purchase point, but there are very few of these standards to rely on. So, as you go through the design process, expect to make changes frequently as you discover the "use" habits of your visitor base. (If you've hired a designer, keep your costs in mind here, and don't necessarily believe that they know best. If that were the case, every website on the net would be designed identically.) People often make the mistake of designing sites with their own web-habits in mind, or based solely on artistic reasons, where design prevails over substance or usability. My most important rule of thumb is this: Going from any one part of your site to another should require as few clicks as possible.

Provide Good Content: Photos are great, but if you can add something "of substance," that can really help. If you can write, give advice, provide helpful links, tell stories, or make your site useful, it will be more popular. What's more, search engines will have even more content by which to index you. (See page 151 for more about search engines.)

Don't Bother with a "Login Page" for Site Access: In fact, don't require people to "register" for anything (except, perhaps for opt-in newsletters, etc.). Statistics show that sites that require registration or any sort of "agreement" to enter are abandoned by a margin of three to one.

Don't Have an Opening "Splash Page": These intro screens or photos whose only purpose is to offer the user a "click to enter" button are just a waste of time. You should consider that any page on your site could be a possible "entry page" if that's where a visitor lands first (usually as the result of a search engine). Expecting people to enter at your "home page" is a mistake, especially if your site is indexed well by search engines. Every page should have links to get to most anywhere else on your site.

Avoid Reliance on Flash or JavaScript: Flash and JavaScript are web tools that allow you to do animations and perform other kinds of neat special effects on webpages. While it's fine for aesthetics, it's really just style over substance. It's not that I advise against the use of such technologies, but sites that can only be viewed with Flash or Java are statistically prone to losing more visitors than they keep. Also, as the Internet becomes more accessible through non-computing devices (like touch-screens, phones, etc.), not every aspect of the traditional mouse/keyboard-based user interface will be present. In short, be judicious about using flashy technology, and try to assure that your site has cross-platform compatibility.

Avoid Using Frames: Frames are used to segment a web browser into sub windows within the main frame so that you can have separate parts appear to do separate things. The menu across the top can be in one frame, and the picture-viewing area can be in the main frame in the middle of the page. As wonderful as they look, and as convenient as they are for the user and other navigation schemes, they are not search-engine friendly, so your site's content is not likely to be indexed at all. Some engines can search through frame content, but most can't. This limitation will probably be resolved as the net evolves, but in the meantime, since getting indexed by search engines is half the battle, don't make that more difficult than it needs to be.

Don't Use Pop-Up Windows: It should go without saying in this day and age, but pop-up windows (ads, slide shows, etc.) are a sure way to lose customers. Because of this problem, people use pop-up blockers to prevent any window from coming up, including those that aren't ads. You may be tempted to use extra windows to display images separately (such as enlargements or other material you really want the user to see), but the user's browser may block them and you won't know it. So, keep everything in the same browser window all the time.

Don't Be Pushy: Nothing turns people off more than a pushy seller. Don't use big fonts, flashy graphics, exclamation points, or money-saving offers. And, by all means, don't design your site as if you expect the person to buy something right off the bat. Providing a shopping cart icon next to each photo is sufficient.

Identify Yourself without Being Arrogant: Obviously, you want to let people know who you are, and you should provide as much contact info as you can to be informative. Provide a bio or resume, but be conscientious about how you portray yourself. Referring to yourself in the third person often appears pretentious: "Dan Heller has built his photo business up from a modest studio apartment to become the worldly traveler and renowned artist for which he is beloved today." See how stupid that sounds? Don't do that. Humility is a very attractive quality, and talking about yourself in the first person underscores that quality: "I started my business at home as a hobbyist and eventually found my biggest inspiration in my travels." This sounds much more believable. The one occasion where you should write about yourself in the third person is when you are writing text for someone else to print about you. If you're going to hang your pictures in a café, or on someone else's website who is featuring your work, these are the times to do it.

Be Active in the Photography Community: People who are active on the Internet (i.e., discussion forums, newsgroups, photo-related websites) and in outside photographer communities (photo clubs, etc.) not only contribute to their careers and knowledge evolution, but also help themselves get noticed. (In fact, it's because I did this that you're reading this book.) In the case of online community participation, just having your name out there will draw in the search engine hits.

Don't Worry About Letting People Use Your Images: Stealing is one thing; promotion is another. While you want to protect yourself from theft, don't throw the baby out with the bathwater by prohibiting or discouraging people from downloading your photos. If you warn people not to download your pictures, you just might be discouraging a graphic designer from using one of your images as a mock-up for an ad layout they're going to propose to a client. This usually turns into big business, and you don't want to stand in the way of that. The money to be made in this business comes from customers who license high-resolution images for use in some sort of media (print or digital). Worrying about downloaded low-res images is putting a huge amount of effort into a slim segment of the business model that yields little money. Sure, you can and should sell low-res images to people who license them for web use, but that business will come, protections notwithstanding. That said, you should watermark your images (using your digital editing software); put your name and website on all the low-res images you have on display so that you and others can identify the images as yours. This is the extent to which this issue should occupy your concerns. (Of course, I strongly recommend copyrighting your images. This is an amazingly simple process, covered on page 28.)

Don't forget that you're a photographer, and the web advertises you. While it was never my intent, it turns out that one of my most effective marketing strategies is to let people spread my images around. These are like free ads that lead people back to my site. (25% of my web traffic is via links from non-search engine sites.) As long as your images have an identifying copyright mark that incorporates your web address visibly, you're going to get a reasonable return of traffic. Private use of my images is the greatest conduit for getting those images in front of the eyes of buyers. Those buyers are either from commercial sites that want to use images for licensing, or individuals who buy art.

search engines: the
holy grail of internet traffic

I've mentioned the value of search engines copiously throughout this chapter. They account for 75% of my traffic, but most new sites rely on search engine traffic exclusively. For example, go to www.google.com and type "photos of sunsets" and look at the first page of results. Most people will look at this first page only and, as they visit each one, they either find what they want, or they search again using different search terms. If you advertise or engage in other self-promotion that brings people to your site, that's great. You should do what you can to optimize this kind of visibility. However, nothing you do will yield the kind of traffic that comes from a highly ranked placement on a search results page.

The question that most people ask is, "What are the secrets to getting search engines to rank me higher?" That's not an easy answer. The problem is, whenever someone thinks of a sneaky way to artificially raise their site's rankings in search results, everyone does it, leveling the field once again. The easiest thing to do is to simply buy advertising space on the search engines so that you are guaranteed placement. But, that can be costly, and if your business isn't general enough to appeal to a wide demographic, you could be paying for a lot of traffic that doesn't turn into sales.

There are ways to help your site improve its rankings, but there are no guarantees. Whatever there is to learn, it's all abundantly available on the "Help" pages of all the major search engines. Don't buy into those email offers that say they'll submit your website to the top 100 search engines for some number of dollars per year—this is a simple task that you can do yourself. Getting your site indexed is not hard; getting it ranked highly is, and it cannot be done artificially; you have to make it "important." Assuming two sites are identical in quality, quantity, and

making your site important

Assuming two sites are identical in quality, quantity, and design, we cannot necessarily assume that they are ranked equally by search engines. The reason for this is that rankings are greatly influenced by how many important sites link to the site in question—in this case, yours. Read this carefully: It's not just the total number of links, but the number of important sites. This distinction illustrates how critical it is to promote your site, but not just anywhere—you need to get it linked to from other important sites. Often, these are highly trafficked sites like photo forums, discussion boards, news sites, industry associations, trade groups, or even high-profile clients. When you license photos, have your clients link back to your site. If you participate in photo critiques or reviews, your website should be part of your signature. If people see your postings, and they talk about you in new discussion groups, your rankings go up.

This "secret" is not really a secret, per se, because it's not a short-cut. It requires diligent work. Indeed, there is a penalty for trying to cheat the system. For example, "link-back programs" (where sites agree to exchange links with as many sites as possible) attempt to raise the rankings of sites artificially by merely cooperating with others to maintain reciprocal links. Since this adds no value for those who are searching for legitimately good content, search engines watch out for this. In fact, sites with "artificially high linking" are ranked lower than sites that don't participate in such schemes.

Now, let's not fool each other here; getting important sites to link to yours is really, really hard. But, it's also the natural by-product of good content and active participation in other net activities. If your images are visible and people want to use them, if people are talking about you, if you are talking to others, and you are doing everything else associated with building your broader business model, then important sites will eventually link in your direction. How long this takes is proportional to the effectiveness of your self-promotion. Some people are better at it than others. It took me about three years before any of the pages on my site created enough of a critical mass of interest that they ranked highly. And even to this day, not every page of my website is ranked highly. It's a volatile world.

back to basics

Content comes in three basic forms: quality, quantity, and design. Quality is first and foremost. The fact that I have marketable material that appeals to the broader general public is pivotal to my success. In my case, I also try to have as much diversity as possible. If I were to only have black and white photos of abstract swatches of cloth, my site probably wouldn't have the traffic and interest that it does. But even diversity isn't enough—the work has to be "good." Yet judging that isn't easy, because "good" isn't consistently the same for everyone. Lest we forget the first rule of artwork: "To each his own." There is a reality about what does and doesn't sell, but it's not always easy to grasp due to cultural and artistic variances. At the end of the day, it's whether your notion of what's good matches with those who visit your site. It should be stressed that you need to be honest with yourself about the choices you make in what you put online. Be proud, but be realistic.

Next, we have quantity. Whoever said, "Too much of a good thing is bad," never designed a website. Having quality images is one thing, but it's the volumes of them that attract more and more traffic. Similarly, uniqueness helps. By that, I don't necessarily mean that images must be unique from the work of other photographers; what I mean is that you should strive to display photos that are unique from each other. I've seen people post 25 pictures of the same, great looking subject, but this isn't helping. So, combining quality and quantity only makes sense if the net sum of it all is a unique enough package that it will hold visitors' interests.

Now that we've covered quality and quantity, it's time to focus on actual design. That is, organizing the images coherently with an intuitive navigation so people can find what they want with the fewest number of mouse clicks. How does this affect your site rankings in search results?

Remember, if other people link to you, your rankings are higher, and other people will be more inclined to link to you if your site is useful and user-friendly as well as attractive. Design involves aesthetics, but that's something photographers almost always put ahead of functionality, so I should warn you not to neglect functionality, which can make or break your site's popularity. Many photographer media organizations give awards for website design, and the winners are almost always those with great-looking and impressive design work, but whose functionality is so limited that it brings very little actual business to the photographer. (The web designers, on the other hand, fare pretty well!)

size matters

I've seen a lot of resistance to putting high-res images on websites, leaving only the smaller thumbnails for visitors to see. The motivation for this is born out of the concern that images will be stolen. Understandable. So the question then becomes: How big do your images have to be before they become "worth stealing?" Also, it's not just a matter of size; there are other usability considerations, as well. Let's address the size issue first.

Long ago, I felt that it was important to keep people from downloading "bigger" pictures in violation of my copyright. When people complained that they just wanted to see them bigger, I wrote it off as a reasonable trade-off between allowing photos to be seen "well enough," and having them stolen. But, the impact on business never really hit me until I got an email from someone that said, "We can't use your images to layout a page we're considering for an ad campaign, and time is tight; can you get us a higher resolution image to use as a prototype?" Because I was away on assignment, I couldn't get to their request in time, and they had to go somewhere else. Ouch.

So, I started linking my low-res images to higher-res versions, and I placed my copyright mark on the side. These "higher resolution" images were only 550 pixels in the long dimension—big enough to see in detail, but nothing that could be copied for print use. I felt happy that I was now able to accommodate a potential client's workflow by allowing them access to what they needed to determine the usability of my work for their projects. The better lesson was yet to come: Bigger images encourage longer visits, more page views, and more interest, all of which translate to more business. The average time people stayed on my site increased from two minutes to thirty. Page views per visit went from 12 to 35. About a month later, orders for prints not only increased, but also became a lot less erratic, and have been that way ever since. The rate became consistent. I've found that the amount of traffic, the number of emails, and the number of orders directly and proportionally increases with the number of high-quality images on my site.

Best of all is efficiency. Rather than having to deal with every request for a high-res image, the work is already done, and I can spend my time doing other things. I don't need to monitor every potential client; I simply need to respond to those who order. In other words, don't irritate your potential customers. They shouldn't need to contact you to download comps, and if they do, you've inserted an annoying, unnecessary (and worst of all, time-consuming) step into their workflow. Plus, their needs interfere with your workflow! (If you have time to deal with constant requests like that, you aren't spending enough time doing more important things.)

payment methods

When designing your site, the highest hurdle you'll face is that of taking payment. At first, the process is easy: Just get a phone number for your client and call to arrange for a check. But then, you figure people like using credit cards, not to mention the fact that the easier you make it, the more sales you'll get, right? There is some truth to the notion that ease of payment promotes sales but, as has been the case with every business aspect we've addressed, it's not that simple.

Don't discount the amount of business one can do on the net without accepting credit cards. In fact, I only just started accepting credit cards in June of 2003, well after I'd past the milestone of $5000/month in print sales back in 1999. Until that point, everyone sent me checks, and even though people would ask if I accepted credit cards, I can't think of any serious buyer that didn't purchase because I didn't accept cards. Sure, I may have missed some spontaneous "impulse purchasers," but then, I also don't use price points that spark an impromptu purchase.

So, for me, that artifact didn't apply. However, my business model may not match yours. If you sell lots of low-priced consumer products, then accepting credit cards should be on your list of necessities for your site.

The key ingredient here is discerning the difference between an impulse purchase and a consultative sale. In an impulse purchase a credit card makes it quick and easy; anything that interferes with this process disrupts the impulse. This isn't the case for the consultative sale, where people want to talk about and discuss an item before they lay out the big bucks. Once they decide, sending a check or using a credit card is of no consequence.

When the time comes that you do want to take credit cards, there are two ways to go about it. First, there is the merchant bank approach. This is just like any other bank, except that their clients are businesses rather than individuals. (However, larger consumer banks often offer merchant banking services, as well.) So, if you are a business, have a tax ID, and have a resale license from your state's franchise tax board, you can apply for a merchant banking account. With this account, you will have access to the tools necessary to accept credit card payments.

Another payment option is PayPal. This is a convenience that many find useful. You can avoid a few administrative headaches by paying PayPal to have them for you. But, this convenience does come with associated fees. The way it works is rather simple: PayPal interfaces with the customer and takes payment on your behalf, depositing the funds into your account, minus their fees. What those fees are varies, but it can be as high as 3% of each sale, which isn't too bad when you consider that they don't require any of the licenses and forms that a merchant bank would. What's more, PayPal's fees have been drift-

ing lower as competition with the merchant banks heats up. (Note that when comparing PayPal rates to merchant banks, keep in mind that the "low" rates that banks charge are usually for "card present" transactions, where you physically swipe the customers card to compete the sale. Rates for Internet transactions are much higher.)

Regardless of whether you decide to accept credit card payments for your online business down the road, beginners should almost assuredly avoid credit card transactions entirely until a stable and moderately consistent sales trend is established. This has nothing to do with fees; it's a matter of biting off more than you can chew during your site's initial development stages. You can delay or even prevent your site from ever getting going if you try to deal with too much at once. Don't worry that you may be losing sales because you don't take credit cards. As I've already stated, I can't think of any serious buyer that decided not to purchase because I didn't accept that one form of payment. A check is almost always an acceptable alternative.

contact with visitors

Bringing people to your site is one thing, keeping them is harder, and having them come back is the hardest. This is why it's important to provide a quick, unobtrusive way to get feedback from them, to be responsive to them when they do contact you, and most of all, to be able to maintain contact. People love contacting photographers about their work, and it's your duty to reply to each and every one of them. Anytime someone asks a question, I reply to it personally. If they have a comment, I almost always reply to those too. Of course, you have to use your time judiciously, which is the hard part. (You can't and shouldn't reply to every 4th grader who asks whether sand in the Sahara Desert really was shipped in from Arizona, despite a joke I once had on my website.) When I answer emails, it's amazing how much positive feedback I get from people that simply say, "Wow, I never thought

I'd get a response from you!" I can appreciate that—I'm offended (and bewildered) when I email a photographer about how much I like his/her work, and I don't get a reply. It shows arrogance, even if that wasn't the intent.

A great way to solicit feedback on your site is to have a feedback form, a page where people can type anything they like and click a "submit" button, which emails their statement to you. Sure, they can send email, but people seem to be drawn to forms. (I've found that feedback forms generate more feedback than email links at the rate of 15:1.) Once you've bought into the "forms" idea, options open up. The simpler the form, the better. "Checkboxes" and "lists" get even better return rates because people don't have to type. Very early in my web-life I had a checkbox under every single photo, and people could check whether they liked it or not. This not only generated good feedback, it kept peoples attention longer because they liked the interactivity. You can also get an accurate sense of how many visitors you get. You may not know what percentage of the total traffic is filling out the forms, but you do know that the more you get, the more your traffic is growing.

emailing: newsletters and announcements

I have an "opt-in" email list that I use to keep in touch with those who want to hear from me. But be careful; in these days of spam and other unsolicited email, you can kill your business if you don't handle email properly. If you do send out bulk messages, make sure you only send to those who want to receive them. What's more, give clear instructions on how to get off your mailing list. (Some who sign up will forget by the time you get around to sending a newsletter, and then they'll think they're getting spam.)

It'll take time for your list to grow, but these people invariably become great contacts for continual feedback, support, and even critique. Many may become clients, too. I send a newsletter once or twice a year, and most people tell me that isn't often enough. (Truth is, I just don't have the time.) If you update your site with new images, that might be a good excuse to reach out to your email base.

summary

Having a photography business requires some sort of online presence, but exactly how much you need is not etched in stone. Your business model will govern the degree to which you should invest in this format. For those who are more technically adept, the more investment you make in a website, the more dividend you'll receive in the long run. For photo businesses that focus on consumer services, like portraits or weddings or other events, the most applicable use of the web will be to allow clients to see your previous works, and possibly to order prints from a session they've had with you. But the common denominator for any photo website is to have at least a sufficient portfolio that represents who you are and what your business function is.

For those looking to do online sales, your e-commerce solution does not have to be an all-or-nothing approach. It's far more important to build it incrementally as your business develops, rather than trying to tackle your final objectives all at once. As for payment, asking for checks is fine; you won't lose business because you don't accept credit cards. When time and efficiency reach a certain point where credit cards make more sense, it should be easy to set up because you've already got a reasonably mature site, where "card technology" could integrate in rather seamlessly. Regardless of what you do online, it should be balanced and integrated with a broader business model. All aspects of the photography business require time to evolve, so don't focus on one over another in such a way that you drag down your progress. Set reasonable goals for yourself, put in the effort, and have some patience, and you, too, can have a successful online photography business.

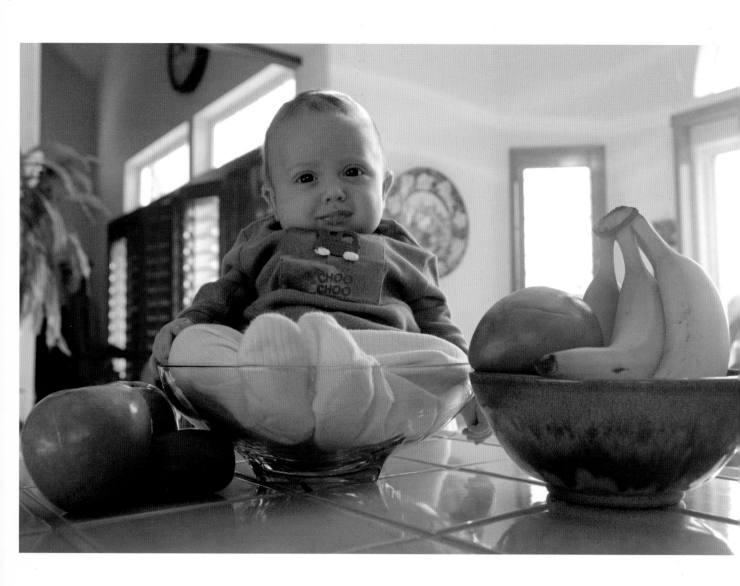

index